EAST ANGLIA'S
LITERARY HERITAGE

———————

CHRISTOPHER REEVE

AMBERLEY

First published 2025

Amberley Publishing
The Hill, Stroud
Gloucestershire, GL5 4EP

www.amberley-books.com

Copyright © Christopher Reeve, 2025

The right of Christopher Reeve to be identified as the
Author of this work has been asserted in accordance
with the Copyrights, Designs and Patents Act 1988.

ISBN 978 1 3981 1085 4 (print)
ISBN 978 1 3981 1086 1 (ebook)

British Library Cataloguing in Publication Data.
A catalogue record for this book is available from the
British Library.

Typesetting by SJmagic DESIGN SERVICES, India.
Printed in Great Britain.

Contents

Introduction

The three counties comprising this compilation, Norfolk, Suffolk, and Cambridgeshire, can boast a large number of celebrated authors, particularly because Cambridge University has been the breeding ground of so many throughout the centuries, and in recent years the University of East Anglia has developed the talents of many writers with its MA Creative Writing degree courses. But in addition, Norfolk and Suffolk, with their large, serene and beautiful rural landscapes, have attracted many others to settle here, so all three counties are continuing to nurture extensive writing skills.

With a prescribed limit of 24,000 words, selecting which writers to be included or discarded has proved to be quite a difficult task. The criteria for my choices is as follows: authors who are native to East Anglia or have spent a major part of their writing careers here; authors who have moved here and have been influenced by an East Anglian region; authors who have visited here and published significant works relevant to the region.

The word restriction doesn't permit much space for each, so what I've aimed to do, like the busy honey-bee, is dip and sip, and offer the reader what I hope is a sweet sample of my enjoyable buzziness and tastings.

There will be omissions that some readers will regret, and maybe even complain about. I have aimed to include the most significant authors connected with the East Anglian region, but particularly those who reflect my personal tastes. Many of the authors featured here provide insight, wisdom, and imagination regarding the human condition, in vivid prose and poetry, which can be permanently imprinted on our minds.

This is the value of reading, and why it's so important to introduce children to story-telling and books from an early age. Story-telling in oral traditions dates back to Saxon times and earlier, and on dark winter nights when families were gathered around their hearth fires, the older members recited poems and legends they had learned from their parents and grandparents, and new tales would be added and invented and passed on to future generations. In East Anglia, one of the best-known legends relates to Black Shuck, the demon hound who haunts the region and has become a widely popularised figure since his startling appearance in my home town in St Mary's Church, Bungay, on 4 August 1577. It was during a terrifying thunderstorm, such 'raine, hayle, thunder, and lightning' as was never seen the like, as the parish records described it. He was believed to be responsible for the deaths and injuries which occurred there and at nearby Blythburgh church on the same morning; and this is not just a fusty, musty old tale, because he is reported to continue haunting East Anglia today. He has become an iconic figure in the town, and it is amusing that he appears as the crest on the Bungay Town Council coat of arms instead of the traditional heraldic lion.

Oral story-telling continued by family firesides for centuries, but tended to die out as the population became more literate during the Georgian and Victorian periods. So

stories were read from books, and it was also a way of teaching children to read from an early age. Bedtime stories continue in many families, comprising a quiet time at the end of the day when parents can relax, and grandparents are also increasingly involved, harmonising the generations together.

My mother always read a bedtime story to we five children, until the youngest had learned to read confidently by herself. Later on, Mummy continued the role with grandchildren, and the result was that all of us learned to read before we attended school and the habit of reading became a lifetime's source of pleasure. I continue to read in bed, by lamplight, for about half an hour every night, before I settle down under the duvet, swiftly soothed into slumber-land by the regular routine.

There is no substitute for the supreme pleasure of losing yourself in the enchantment of an engrossing book. Not just the relaxation and delight it provides but because the story, or poem, can sing in your head as a permanent source of inspiration. My mother was an avid reader, and learned reams of poetry by heart. They provided much comfort in her old age, in the long dark nights, often in pain, when she would murmur them to herself or aloud until blissful sleep ensued.

I hope that this book will introduce you to many authors you may come to love, to enrich your lives as her life was enriched, as mine has been also.

Norfolk

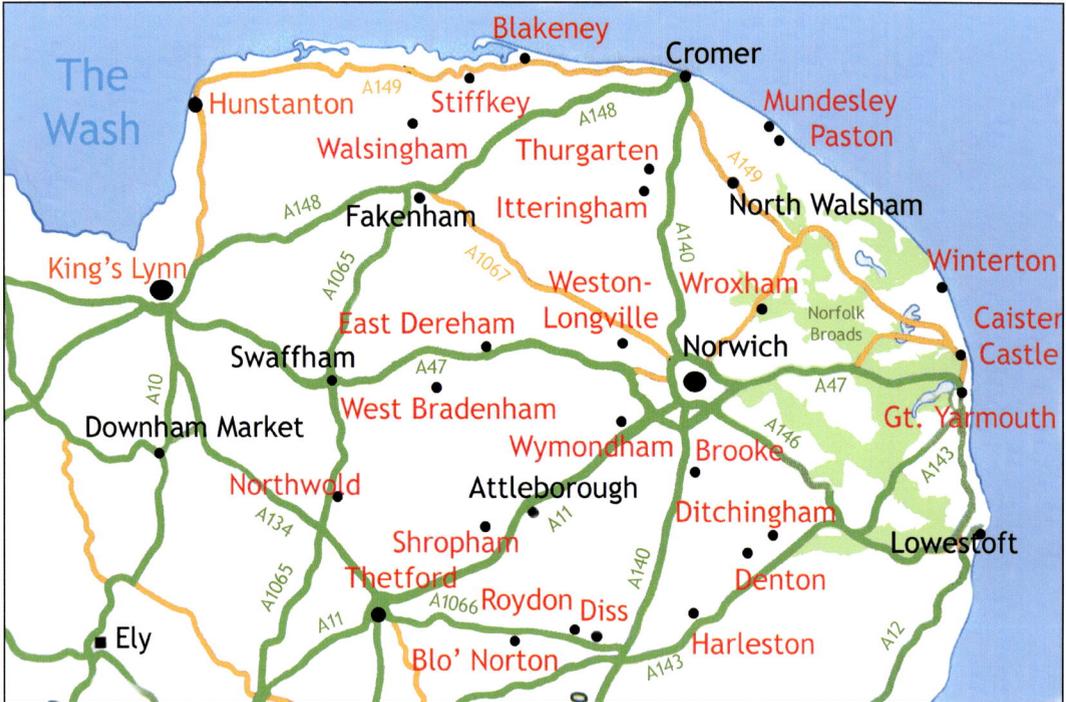

Map of Norfolk by Karen Leah.

Waveney

We will commence with the Waveney area because it's my native territory where I was born and bred, well known and well loved for seventy-five years.

The River Waveney forms the county border between Norfolk and Suffolk, stretching from Redgrave in Norfolk as far as Burgh Castle and Breydon Water, where it flows into the tidal current continuing to the North Sea, at Gorleston on the coast. The distance is around 59 miles. The river begins as a narrow channel, a widdle in a ditch, and gradually widens or narrows as it flows through varying terrains, finally becoming a broad, swift waterway at Beccles where it connects with the Norfolk Broads.

The largest place, a few miles from the source of the river, is the market town of Diss. It is set atop a hill, surmounted by the ancient church, St Mary Virgin, and the ancient pub the Saracen's Head, and at the base of the hill is a large and attractive mere, 6 acres in size.

Source of the River Waveney at Redgrave.

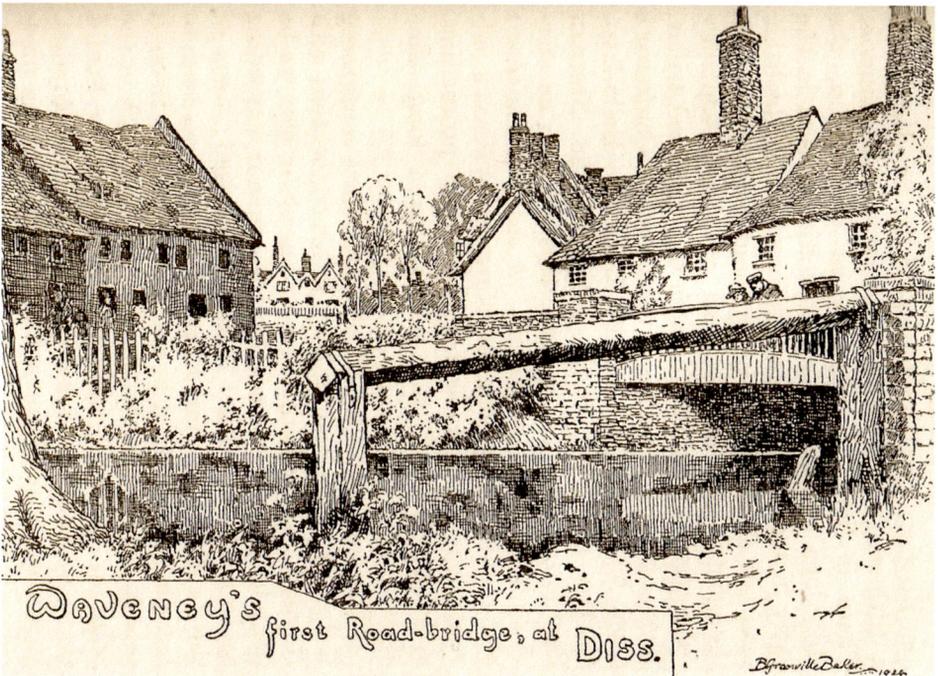

Engraving by B. Granville Barker, 1924.

The earliest writer of importance in Diss is **John Skelton**, who became rector of St Mary's in 1498, a post he retained until his death in 1529. He became a celebrated poet, his skill at verse resulting in his appointment as Poet Laureate for both Oxford and Cambridge universities. For a period he was also tutor to Prince Harry – later King Henry VIII – and gained celebrity in court circles for his rhetorical verses. He has subsequently been regarded as the most significant English poet between Chaucer and Spenser.

His style, known as 'Skeltonics', tends to have short lines, repetitive rhyme endings, and use of contemporary vernacular speech. One of his best-known poems is 'Phyllp Sparowe', 1505, which is the voice of young Jane Scrope (or 'Scroupe'), a resident of the Benedictine nunnery of Carrow in Norwich, lamenting the death of her pet sparrow eaten by the nunnery cat, Gib.

> That vengeaunce I aske and crye,
> By way of exclamacyon,
> On all the hole nacyon,
> Of cattes, wylde and tame –
> God send them sorrowe and shame !
> That cat specyally,
> That slew so cruelly,
> My lytell pretty sparowe,
> That I brought up at Carowe.

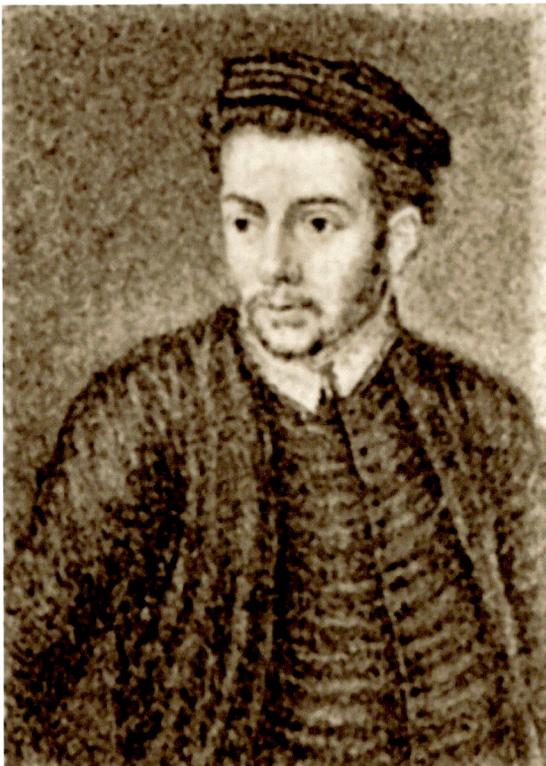

John Skelton. (© Norfolk Studies Library, Norfolk County Council)

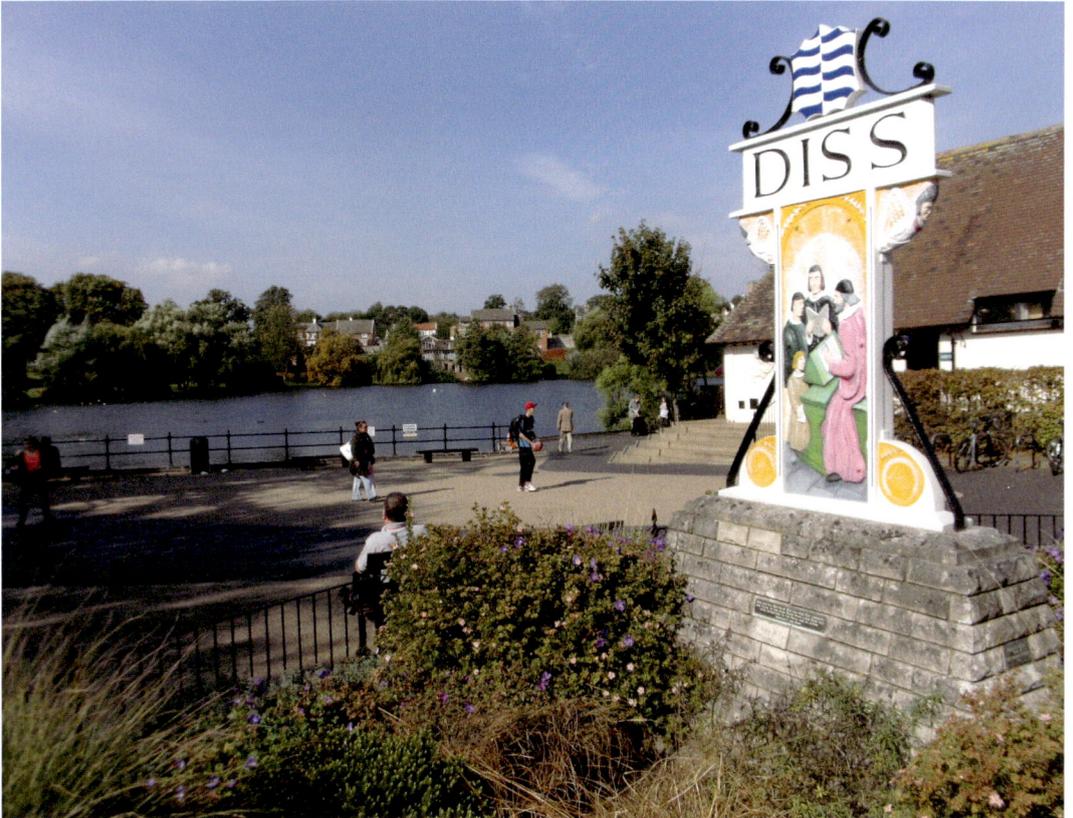

Diss town sign and the mere.

The other poet associated with Diss, as a visitor, not a resident, is **Sir John Betjeman** (1906–84). He had become a successful and popular poet by the 1930s, and his *Collected Poems* (1958) sold 100,000 copies, an amazing triumph for a volume of verse. He was knighted in 1969 and became Poet Laureate in 1972.

He first got to know Diss in 1963, when he was employed to present a series of documentaries on market towns by the BBC. He was very concerned with retaining the character and uniqueness of the rural dwelling areas, and described Diss as 'the perfect small English town'. He went on to accept the honour of becoming the Patron of the Diss Society, which had been formed to resist unsympathetic planning developments, due to threatened London overspill plans.

He became a friend of Mary Wilson, a native of Diss and wife of the Labour Prime Minister Harold Wilson. Their planned visit to the town resulted in an exchange of verses, of which Betjeman's commences:

Dear Mary, Yes, it will be bliss,
To go with you by train to Diss,
Your walking shoes upon your feet;
We'll meet, my sweet, at Liverpool Street.

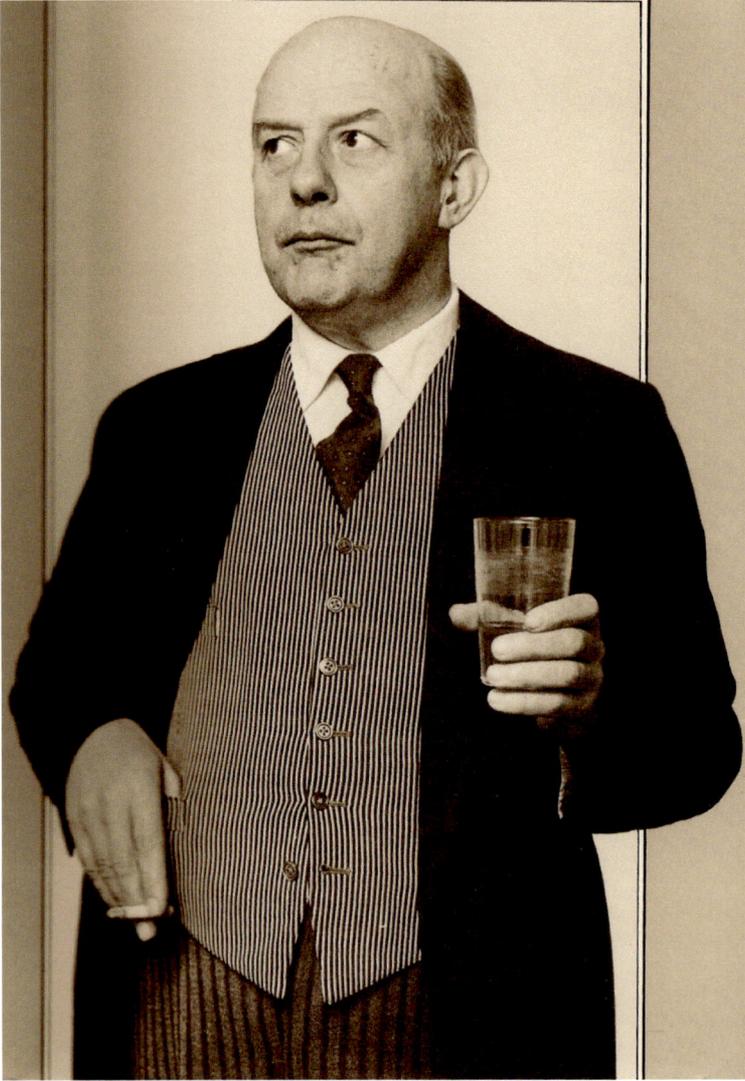

John Betjeman.
(© Popperfoto;
Penguin
Books Ltd)

A most banal beginning, and the remainder of the poem doesn't get much better. Fortunately, Mary Wilson didn't continue as a muse for Betjeman, and a much better poem is one entitled 'Norfolk' (1958), reminiscing about a childhood holiday with his father on the Norfolk coast, which you can find in his *Collected Poems*.

A short distance from Diss is Blo' Norton, where **Virginia Woolf** (1882–1941) spent a month holidaying in Blo' Norton Hall, a moated Elizabethan manor house, with her sister in August 1906. The house and its history provided the setting for the story she was currently writing, 'The Journal of Mistress Joan Martyn'. She greatly enjoyed her vacation, exploring the local countryside, and recording in her diary how she was 'leaping ditches, wading rivers, falling into the mud', where 'the fen plays you false at every step ... and making out beautiful stories every step of the way'. She also took a bike ride to Thetford, an hour's journey away, and affirmed that Norfolk

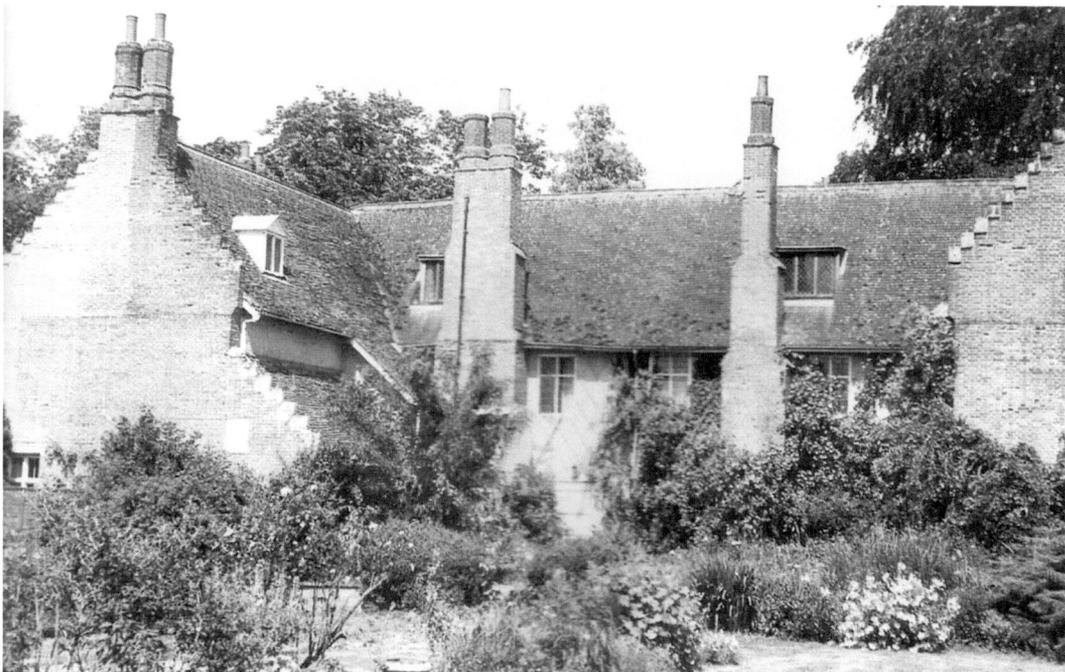

Blo'Norton Hall.

is 'one of the most beautiful counties - a strange, grey green, undulating, dreaming, philosophising & remembering land: where one may walk 10 miles and meet no one ... it is so soft, so melancholy, so wild, & yet so willing to be gentle' (*The Early Journals, 1987–1909*).

Travelling further along the Waveney Valley, we reach Mellis where **Roger Deakin** lived and a short distance away at Roydon lived his friend and fellow nature enthusiast Richard Mabey. Roger (1943–2006) bought Walnut Tree Farm in 1968, a sixteenth-century building in a ruinous state, situated on the edge of Mellis Common near Diss. He entirely renovated it, with little assistance, and settled down to write and enjoy everything that the Waveney Valley has to offer – especially the river. His supreme relaxation and pleasure was 'wild swimming', and, having 'travelled amphibiously' around much of Britain, he swam regularly in various parts of the Waveney, as well as in the moat around his farmhouse, where he would take an early morning plunge, and in the sea in Norfolk and Suffolk's coastal areas.

Previously to settling in Mellis, he had travelled widely, exploring the environment and observing nature, the landscape and wildlife, recounting his enthusiasm and joy in two books, *Waterlog*, and *Wildwood*. In Mellis, for the last six years of his life, he kept a regular diary. Selections from it were published after his death, *Notes from Walnut Tree Farm*. One of the most heart-warming aspects of these diary jottings is the compassion he feels for all living things, from the tiniest insects, to the birds and animals he observed every day on his various walks, and his own household cats. When he found an ant wandering around his writing desk 'in a baffled sort of way',

he is concerned about it, as it has obviously got lost from its ant encampment in the garden:

> I can't help it with directions, as I don't know where it came from... I could simply put it outside, but it is cold and rainy out there, not ant weather at all, so it is better off in here, although I worry that I may accidentally squash it under a book.

And when cutting his lawn he used a scythe rather than a mowing machine, in the belief that it would be less harmful to the insects inhabiting it.

Jacket dust-wrapper, *Notes from Walnut Tree Farm*, Roger Deakin (Penguin books, 2009).

Richard Mabey, born in 1941, lived and was educated in Berkhamsted. He later became a college lecturer, and then Senior Editor at Penguin Books. He had early developed a keen interest in natural history, and came to know and love Norfolk, when in the early 1980s, as he describes in his autobiography, *Home Country* (1990), he stayed with friends living in an ancient lifeboat converted into a residence, and moored at Blakeney Quay on the Norfolk coast. He spent much of his time in the region in the 1960s and enjoyed scavenging for food along the shoreline, resulting in the writing of his first book, *Food For Free* (1972), a popular success, and attracting people to aim at self-sufficiency as an escape from materialistic urban lifestyles.

He became an increasingly acclaimed writer, with his biography of the naturalist Gilbert White and his comprehensive study of indigenous flowering plants in Britain, *Flora Britannica*, winning national book awards.

In 2002 he moved to Norfolk, at a time when he was suffering from acute depression, which he was later able to express in *Nature Cure* and how the flat serene water-meadow environment of the Waveney Valley played a part in his slow recovery: 'What healed me … was a sense of being taken not out of myself, but back in, of nature entering me, firing up the wild bits of my imagination.'

He now lives in Roydon near Diss, and since 1972 has written more than thirty books. He is a patron of the John Clare Society, and frequently quotes from Clare's nature poems

Jacket dust-wrapper, *The Common Ground*, Richard Mabey (Hutchinson & Co., 1980).

in his own publications. He is president of the Waveney & Blyth Valley Arts group, and was made a Fellow of the Royal Society of Literature in 2011.

Continuing past Harleston, a small town with an attractive and varied shopping centre, the river broadens, and our next Waveney author of note is **Louis de Bernieres**. He was born in Surrey in 1954, and achieved critical and popular acclaim with his novel *Captain Corelli's Mandolin*, which won a Commonwealth Writers Prize and was made into an acclaimed film. In 2000, he settled in Denton, a little hamlet set amid agricultural land between Harleston and Bungay.

Denton is close to Flixton, chiefly acclaimed for Flixton Hall, which was the grandest stately home in the region. Dating from 1616, it was virtually destroyed by fire in 1846, rebuilt, but later sold by the Adair family and sadly demolished in 1952. The author connected with the Flixton area is **Elizabeth Smart** (1913–86). She was born in Ottawa, Canada, spent a period of travelling including in America, and fell passionately in love with the poet George Barker (*see* Norfolk section), initially as a result of being deeply affected by a volume of his poetry. They lived together in the States, where Barker had university teaching posts. He was already married, but she had four children by him.

It was their love affair which inspired her poetic prose novel *By Grand Central Station I Sat Down and Wept* (1945), dealing with the most acutely painful of all human experiences, that of unrequited love. The paperback edition, published by Panther in 1966, has an introduction by Brigid Brophy, in which she describes it as one of the half-dozen masterpieces of poetic prose in the world; 'one of the most shelled, skinned, nerve-exposed books ever written'. The character recounting her experiences in the novel realises that her passion is valued as less important to her beloved than his attraction for 'a printshop boy with armpits like chalices'.

Elizabeth retired to live in a rural cottage, The Dell, near Flixton, Bungay, and although she continued writing – a volume of poems in 1977 and later published some journals – she never repeated the unique intensity of her first book. In Flixton she developed a passion for creating and nurturing her garden, which is reflected in some of her diary entries in *On the Side of the Angels* (1994).

She was buried in the churchyard of nearby St Cross, South Elmham, and a slate gravestone bears the inscription from the Roman poet Horace: *'Non Omnis Moriar'* – 'not all of me dies'.

The region between Redgrave and Bungay is populated with several fine Saxon and Norman round-towered churches. They include Syleham, Thorpe Abbots, and Rushall, so if you are touring the region do aim to visit some of them. They are usually unlocked during the day, and you should be able to find an ancient half-timbered pub nearby for refreshments.

Sir Henry Rider Haggard (1856–1925) is the most prominent writer and novelist of the Waveney Valley region. He was born at Wood Farm, West Bradenham Hall, a 400-acre farming estate, and educated at Ipswich Grammar School. He spent some time employed in South Africa, involved in various activities including running an ostrich farm.

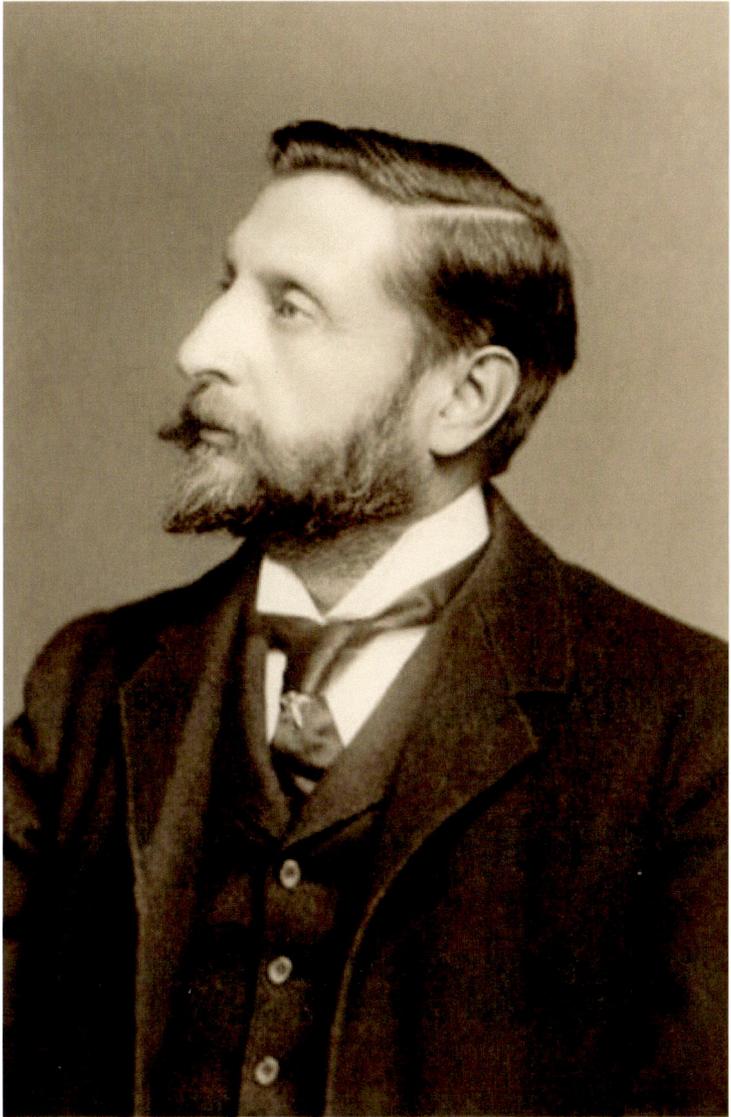

Sir Henry Rider Haggard. (Courtesy of the Trustees of Bungay Museum)

By 1879, he returned home to West Bradenham and married a local girl, Louisa Margitson, who inherited her father's 240-acre farmland at Ditchingham on the Norfolk/Suffolk border. In 1882 the couple moved into Ditchingham House, where Haggard developed an interest in farming the estate. In 1885, having been inspired by the success of Robert Louis Stevenson's adventure novel *Treasure Island*, he decided to write his own adventure tale for boys, which was rapidly completed in six weeks: *King Solomon's Mines*.

It was an immediate success, selling 31,000 copies in its first year, and bitten by the writing bug, he swiftly went on to publish three further novels, *She*, *Jess*, and *Allan Quatermain*, all completed by 1887. In a committed writing career he went on to publish fifty-eight novels, and seven books on agricultural and social history subjects, including *A Farmer's Year* (1898) and *A Gardener's Year* (1905).

He was knighted in 1912 for his various commissions investigating the national state of agriculture and farming, and also awarded the KBE in 1919. Following his death in May 1925, his ashes were interred in the family vault in the chancel of Ditchingham Church. The *Eastern Daily Press* obituary described him as 'one of the most prolific and versatile authors that Norfolk has ever seen'.

Lilias Rider Haggard (1892–1968) was Haggard's daughter, born in Ditchingham Hall. She followed her father's example by becoming an author, initially writing regular articles for the *Eastern Daily Press, Diary of a Norfolk Countrywoman*. These proved very popular and were later published in three volumes: *Norfolk Life* (1943), edited by Henry Williamson, *Norfolk Notebook* (1947), and *Country Scrapbook* (1950).

She wrote very beautifully about the Waveney landscape she inhabited, spending the spring and summer months in the Bath House, a former inn attached to an eighteenth-century spa for hot and cold bathing cures. It nestles beneath a steep hillside slope on the Haggard estate, adjacent to the Waveney river and with superb views over Bungay's Outney Common.

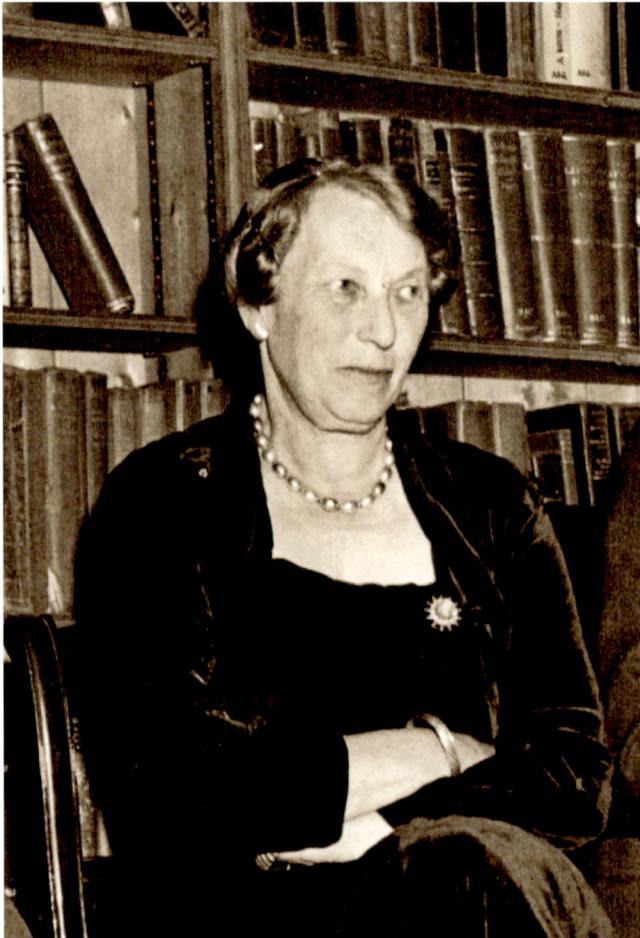

Lilias Rider Haggard.
(Courtesy of the Cheyne family, Ditchingham)

In September, 1939, she wrote:

Most Sundays in the summer we have tea in the Bath House garden. I went down early and sat on the river steps looking at the Common lying in a pool of golden light, light of that liquid clarity only seen when there is rain in the air. The cattle were all moving one way, rounded bodies sleek with summer grass, drifting past in long lines.
The woods were very quiet. Only the occasional clap of wood –pigeon's
 wings, the fretful kee-kering of the young kestrels, or the shrill outcry of the Little Owl. The sudden thump of an apple on the grass startled Jeremiah, the tortoise, who with considerable deliberation was browsing on clover. He drew in his head with a snake-like hiss, and a robin nearby cocked his head, let fall a broken tinkling stave of song, and was gone.
 The garden is full of fallen apples, the nuts are turning brown, the purple elderberries are almost stripped by greedy blackbirds, the crab apples hang like little gold and scarlet lanterns on my small trees, and the plover, packed for the winter, stream overhead with wild crying and the whip of ragged wings. Such a very little time ago it was spring, the apple blossom was out, the cherries in flower, and the Common gay with kingcups.

A Norfolk Notebook (1946).

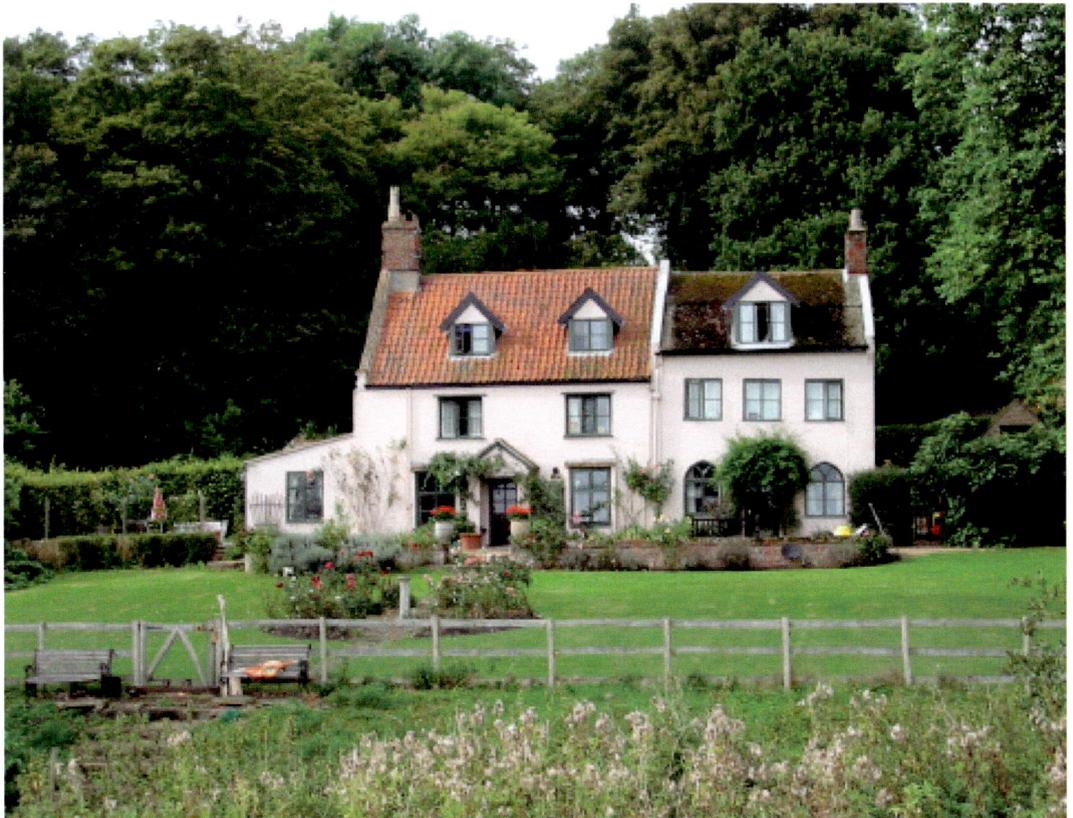

The Bath House, Ditchingham, home of Lilias Rider Haggard.

In addition to her diary jottings, she published a biography of her Victorian Hartcup ancestors, *Too Late For Tears*, and in 1951 a biography of her father, *The Cloak That I Left*. She also edited books of the memoirs written by two largely uneducated men with whom she was acquainted due to their connections with the Ditchingham Hall estate: *I Walked by Night* by Frederick Rolfe, and *The Rabbit Skin Cap* by George Baldry.

Rolfe was a notorious local poacher, always in trouble with the law, and appearing at court sessions which Rider Haggard chaired in his role as local JP. In his latter years he lived in a cottage in Bridge Street, Bungay. His book is subtitled *The King of the Norfolk Poachers*, and for him, poaching wasn't just a means of supplementing the meals for his impoverished family, or a sport, but a lifelong passion. He positively enjoyed trying to outwit the landowners, gamekeepers, and police who always kept a vigilant outlook for him. He had a single-barrel .410 air rifle which could be folded in half so he could quickly stuff it down the inside of his trousers if he saw a threatening character approaching. It is now on display in Bungay Museum, together with his handwritten notebook of memoirs.

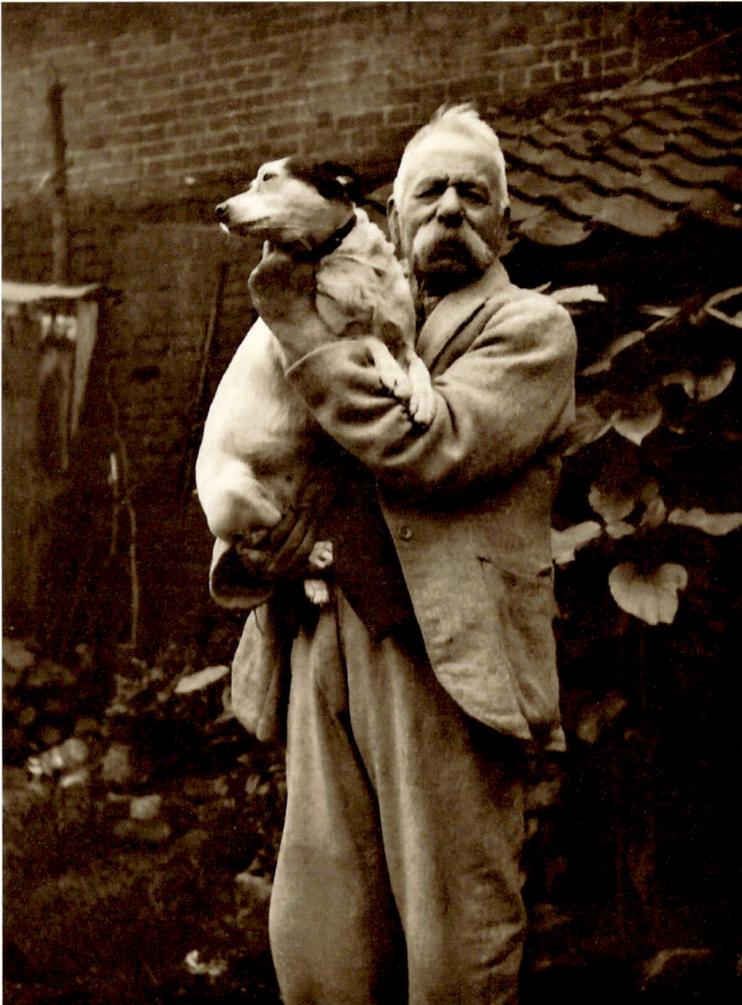

Frederick Rolfe, poacher. (Courtesy of the Trustees of Bungay Museum)

Lilias was impressed with the unique and colourful record of his life and varied exploits, and arranged for it to be published in 1935, providing the introduction and commissioning a portrait frontispiece and line drawings by the celebrated Norfolk artist Edward Seago. The book was an instant success.

Whereas Rolfe was a loner, with a difficult and sometimes cruel character, domineering and aggressive towards his women folk, and on one occasion hanged his own pet dog, George Baldry was very different: genial, always willing to help others, and much loved by the young people who hired the rowing boats he provided during the summer.

He occupied a little cottage formerly attached to a watermill on the Haggard estate, and adjacent to Bungay Common. His father gained only a small subsistence as a shoemaker, so there was always a struggle to keep the family fed, and poaching was a means of supplementing their meals. Later on, Lilias employed George for various tasks, as he was an energetic and practical individual whom she held in high respect. His memoirs, which she edited and had published in 1939, are lively and entertaining, describing his boyhood escapades, various rural occupations, and the local characters he encountered.

There is an amusing account concerning the loss of his treasured cap. One day he fell from a bridge on the Common into the river, soon scrambled out, but saw the rabbit-skin cap floating away. A black dog appeared hunting for rats in the riverbank, so,

I sent arter him arter it, he swam and soon got it to my delight and come ashore with it, biting and shaking it as if it was a rat – but when I runned to take it, he was orf across the

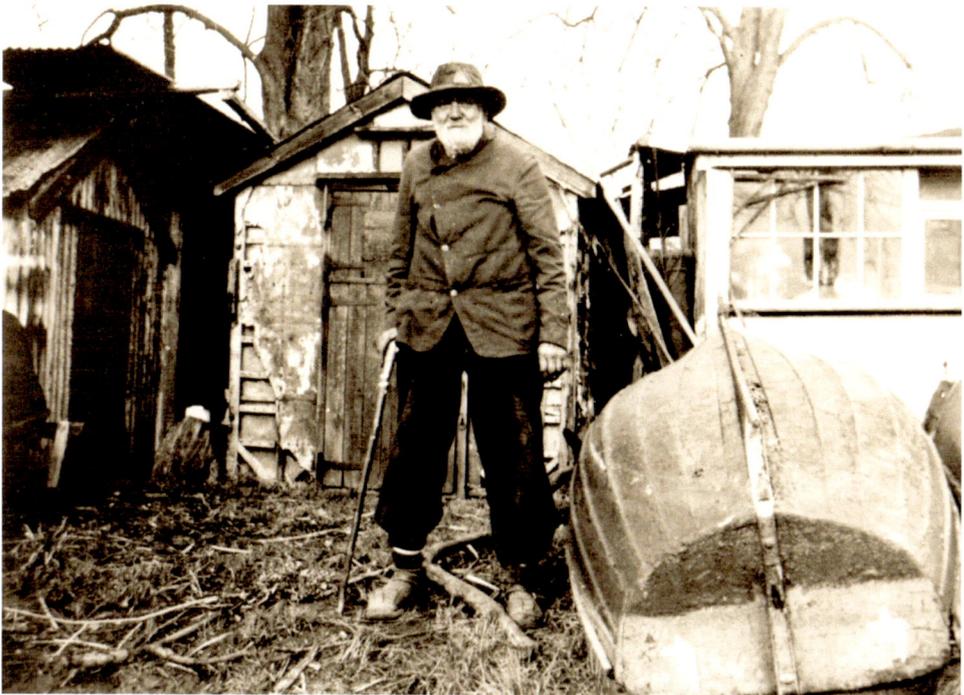

George Baldry depicted at his boatyard on the banks of the River Waveney. (Courtesy of Bungay Museum)

medder and I never seen it agin. Looked to me as I was in for a throshing, wet through and lost my cap which my mother made me from a rabbit-skin, cut in four quarters and sewn together . . like a half coconut. Kept very quiet at dinner, but no one notices my clothes or that my cap was gone ... Later, she comes into the yard, and says – 'Boy ! put your cap on !' and I say – 'I can't as it's lost – a dog runned away with it, and she says, 'Don' tell me that nonsense, unless you throwed it to him – tell me the truth or I'll give you one of the most tarnshing wallopings in yer life'.

So I had to tell her what happened, and she felt my clothes and they were still wet, and off I had to go to bed while they dried.

'No more rabbit skin caps,' she says – 'du I make you one out of your father's old cord trousers will be plenty good enough'.

Similar to Rolfe's book, it has Seago illustrations, and has acquired classic status and is still in print. Both books provide a compelling insight into the wretched lives of the rural labouring classes during a period of acute economic depression.

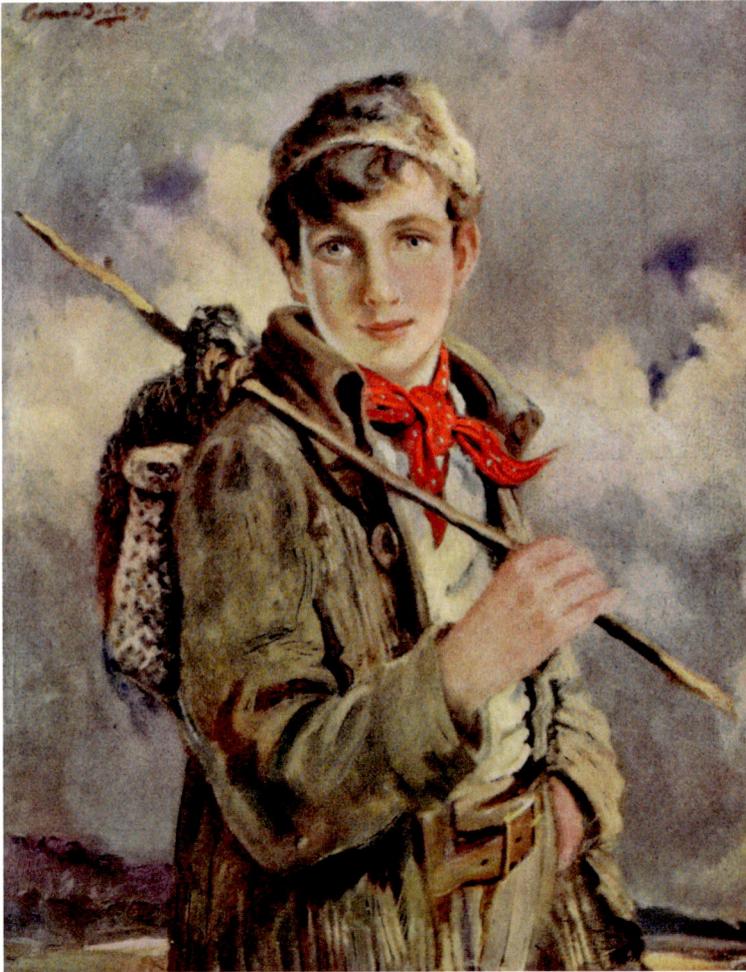

George Baldry – colour frontispiece by Edward Seago in *The Rabbit Skin Cap* (London: Collins Press, 1939).

Norwich

Norwich is the capital of Norfolk, and following the Norman Conquest in 1066 it began to attain the status of the nation's principal city apart from London, when the Norfolk bishopric established in Thetford was moved to Norwich in 1096. By around the late twelfth century the new cathedral with its impressive lofty pointed spire was dominating the skyline. In addition King William I ordered the building of a castle stronghold, on an artificial mound, which also by the twelfth century was dominating the area around it, a massive square keep built of Caen stone. These two very different edifices continue to command the city scene today.

Norwich has a very strong 'spirit of place', and I never visit the city without a feeling of joy surging up in my breast. I have a long association with it, as my first employment after leaving school was working in bookshops in the city, and later on I had a house share there, and now I regularly continue to visit because it is close to my home town of Bungay.

So a lot of my feelings relate to happy memories, but I am convinced it's not just that; it is a magic spell that the atmosphere of the ancient centre weaves, and never fails to enchant – not only me, but various friends with whom I often visit.

Saint Julian of Norwich (*c.* 1342–1413) is perhaps the earliest important writer living in Norwich, and her *XVI Revelations of Divine Love* is the first book known to have been written by a woman in English. Little is known about her life, her real name, and family history. She may have spent a period at Carrow Abbey, the ruins of which still survive in Bracondale, Norwich, receiving education from the Benedictine nuns based there. What we do know is that following a severe illness, she experienced the divine 'Revelations', in March 1373, which transformed her life and thenceforth was entirely focused on contemplating, and communicating with, the Christian God and Jesus Christ. So she became a recluse, retiring to a small cell attached to the little church known as St Julian's, situated off King Street in Norwich.

Although living a solitary life, never leaving the cell until her death, it is thought that there was a 'squint' window in the cell wall providing a view into the church nave so she could observe and be involved with the church services and liturgy, and another small window on an outer wall through which visitors and acolytes could converse with her and offer gifts of food and money. It is assumed that she had a contemporary version of the scriptures, and perhaps a few prayer and devotional books to aid study and reflection.

According to the medieval *Ancren Riwle* for recluses, she was permitted to have a servant providing food and to look after her welfare: two meals a day, but avoiding meat and lard, and she could have a pet cat. The cat is depicted in the beautiful stained-glass window commemorating Julian in Norwich Cathedral. The little we do know about her is due to an invaluable account written by another 'mystic', Margery Kempe, who visited and conversed with her.

The *Revelations* were not published until 1670, and each of the sixteen visions is described, with her reflections upon them, the responses she made to God, and her explanation of their significance for her.

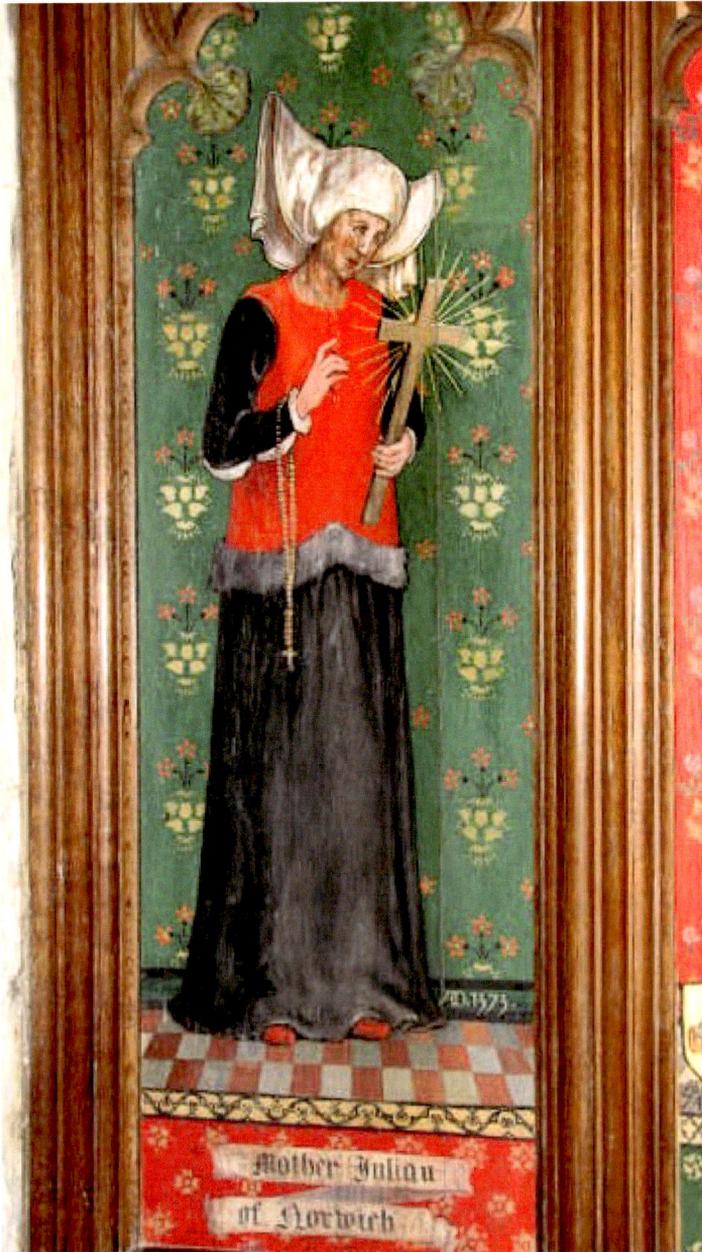

Julian of Norwich –
medieval painting.

Being a woman, it seems she experienced a unique vision or 'Showing', as she expressed it, of God the Father as a loving and caring deity, which influenced later theologians. Previously the dominant male writers on Biblical subjects had tended to conceive of God as stern, demanding, and unforgiving in his judgements upon sinners.

The church, and her cell, were mainly destroyed by bomb damage during the Second World War. Her cell was rebuilt as a more spacious chapel, for the benefit of visitors, but not featuring the original 'squint' windows.

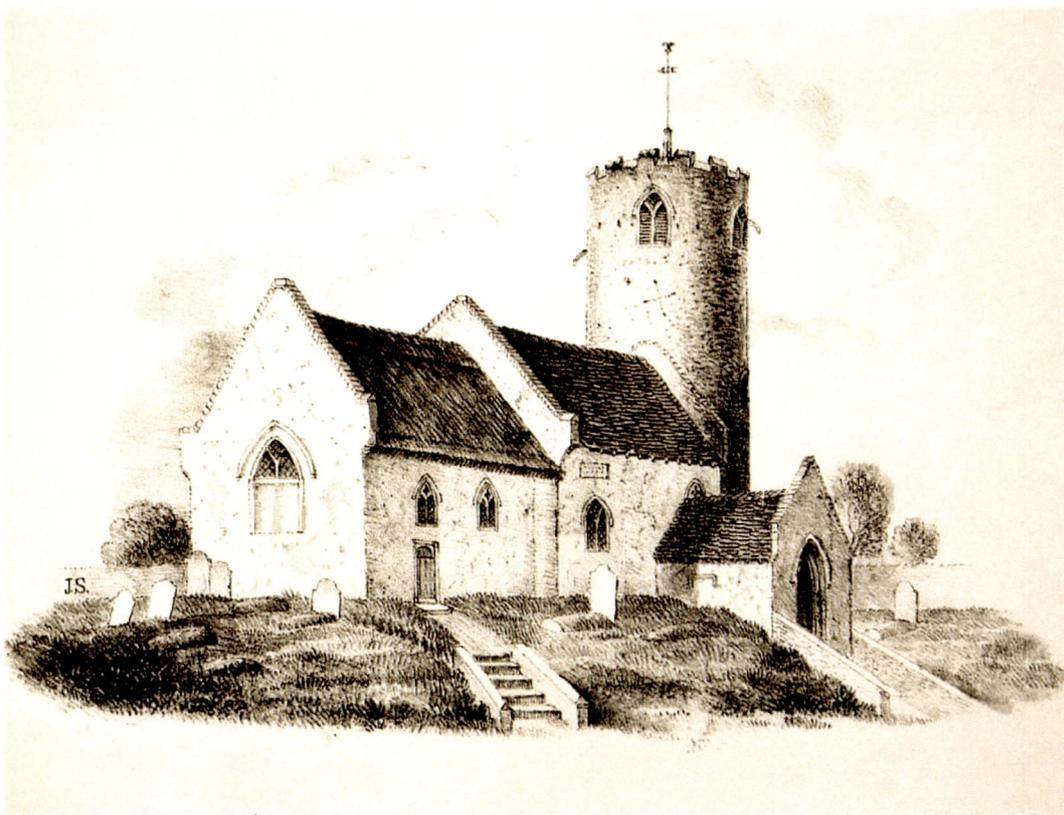

Engraving of St Julian's Church, Norwich, eighteenth century.

Robert Greene (*c.* 1560–92), dramatist and poet, was born in Norwich and baptised in St George's Church, Tombland. He was educated at the Grammar School, founded in 1250, now known as the Norwich School in Cathedral Close. Then he studied at Cambridge University where he commenced writing plays and romances, 'often tedious and insipid, but they abound in beautiful poetry' (Chamber's Biographical Dictionary, 2007). The plays that he wrote were significant in influencing the development of English drama. He moved to London, where he attained fame, developing new audiences for his theatre productions, the most popular being *Friar Bacon and Friar Bungay, c.* 1591.

In the following year he published a pamphlet entitled *Greene's Groat's – Worth of Witte*, launching an attack on William Shakespeare, it would seem from jealousy of the acclaim that the dramatist was beginning to gain, and describing him thus:

> There's an upstart crow, beautified with our feathers, that, with his tyger's heart, wrapt in a player's hide, supposes that he is as well able to trumpet out blank verse as the best of you...

But it's the 'upstart crow' who is celebrated today, not the tawdry fowl who berated him.

Sir Thomas Browne (1605–82) was born in London and educated at Pembroke College, Oxford. He studied medicine, and graduated as a Doctor of Medicine at Leyden in the Netherlands and then continued his studies in Oxford.

In 1671 he moved to Norwich, where he remained for the rest of his life. His first and most acclaimed and popular work was *Religio Medici*, completed in *c.* 1635, although the authorised edition was not published until 1643. It comprises a meditation on his personal Christian faith and his inner spiritual life. Although it was widely read and influential in developing religious meditative worship for many readers in past centuries, it can seem somewhat abstruse for modern tastes now that we are not so much in the habit of daily religious prayer and study as our ancestors were.

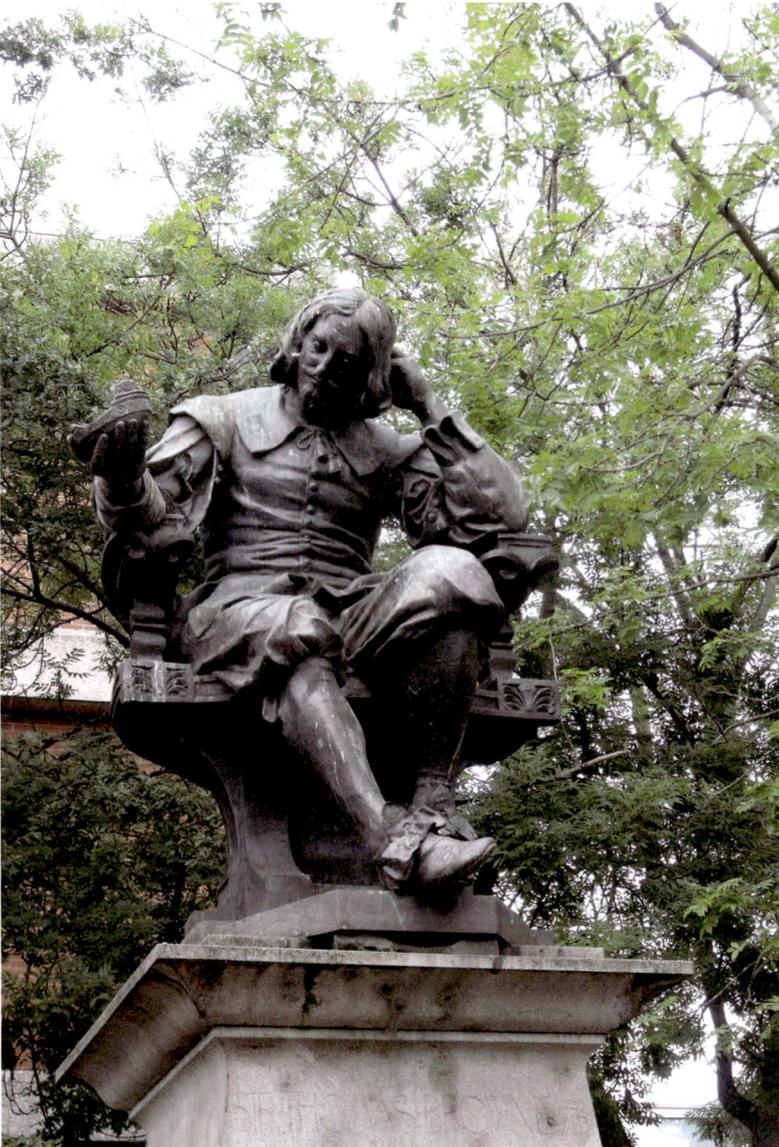

Sir Thomas Browne,
bronze statue,
the Haymarket,
Norwich.

Hydriotaphia, Urn Burial was published in 1658, and has been identified as the first archaeological treatise in English. His prose style was greatly admired by Virginia Woolf, as described in *The Common Reader* (1925), in the essay entitled 'The Elizabethan Lumber Room' praising him as 'the first of the autobiographers', and that with him 'we are in the presence of sublime imagination'.

Browne was knighted by King Charles II when the monarch visited the city in 1671. The eminent diarist John Evelyn visited him in that year and describes his house as 'a paradise and a cabinet of rarities'.

Browne was buried in St Peter Mancroft Church, on Hay Hill in the centre of the city, and there is a memorial tablet on display.

A large and impressive bronze statue is situated near the church, and it faces towards the Haymarket house where he resided, near the present Lamb Inn. The house was demolished in 1852, but a handsome carved oak mantelpiece from the drawing room survives and is on display in Norwich Castle Museum. Being in the centre of the city near the market, the statue attracted the attention of city students, who at weekends loved to swarm up it, decorate it with Santa Claus hats at Christmas and other funny garb, and regularly filling the adjacent pool and fountain with washing-up liquid, which the wind whirled up into bubbles in the air. Such Fun! And a student at the city art college, as a project, created a temporary wooden house structure for Sir Thomas to inhabit – quaint and amusing. Let's hope that her college tutors were impressed.

George Borrow (1803–81), novelist and travel writer, may have been born in Norwich when his father, during his army career, had temporary accommodation in the city, but Borrow himself claimed that he was born in East Dereham. From 1816, the family were certainly in Norwich in the house named Borrow House in Willow Lane. George was educated at the King Edward VI Grammar School, now named the Norwich School, and disliked the harsh regime, which included frequent thrashings for any misdemeanours. So he left when he was sixteen, and commenced study in the legal profession. However, he was much keener on learning foreign languages, fuelled by a burning desire to travel widely. He mastered sixteen in total.

During his regular walks around Norwich he met up with travelling gypsies, encamped on Mousehold Heath, and befriended them, entranced by their free-wheeling lifestyle. The Romany language was one he learned so that he could fully converse with them. His pedestrian travels around Britain, often living rough, resulted in *Lavengro* (1851), which provides accounts of the lives of gypsy folk, and *Romany Rye* (1857) continues in the same vein. Neither book proved popular with contemporary literary critics, but later on they gained more acclaim and have become popular classics.

By 1824, he left Norfolk, being keen to commence travelling widely and establish a career as a writer. He describes himself in verse *in Romantic Ballads* (1816):

And sixty miles a day can walk;
Drink at a draught a pint of rum,
And then be never sick nor dumb;
Can tune a song and make a verse

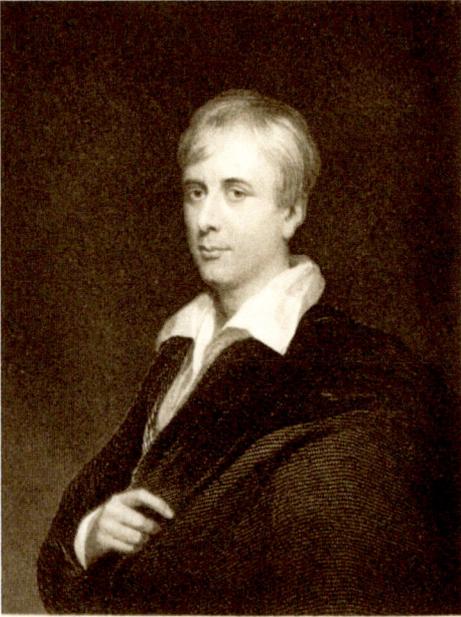

Left: George Borrow, portrait from *Lavengro*.

Below: Birthplace of George Borrow at Dumpling Green.

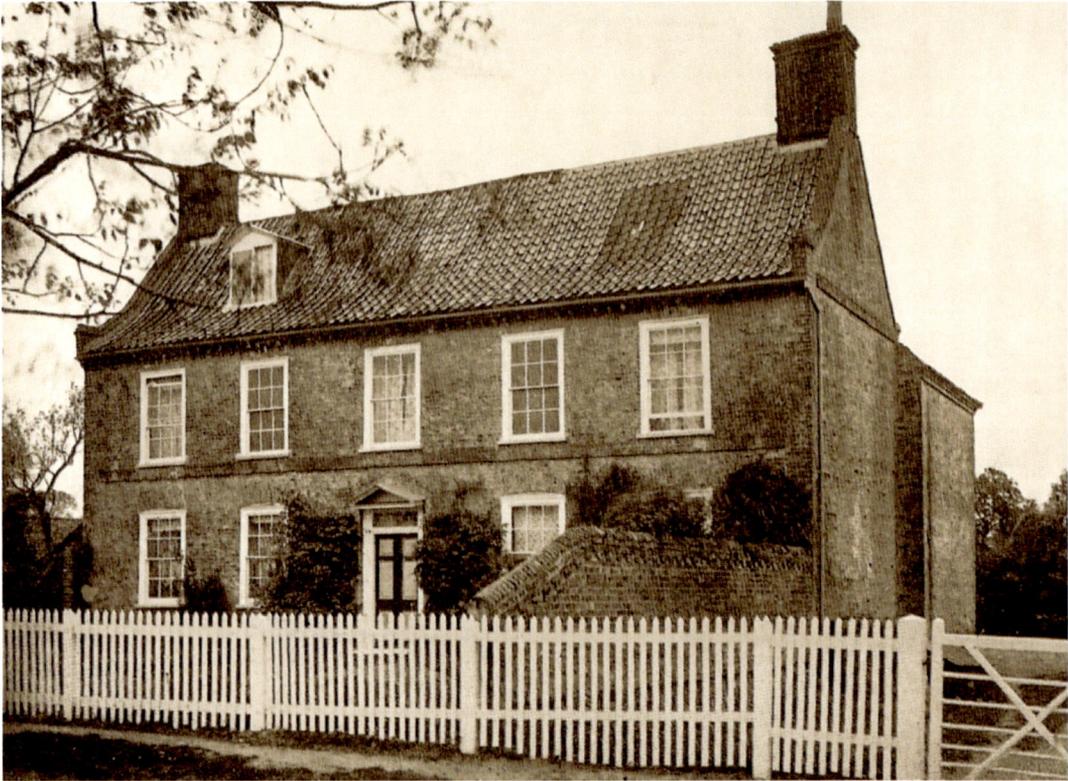

Norwich Grammar School, Cathedral Close, Norwich, where George Borrow was educated.
Watercolour by Walter Dexter, *Some Literary Associations of East Anglia*, W. A. Dutt, 1907.

And deeds of northern kings rehearse;
Who never will forsake his friend
While he his bony fist can bend,
And though averse to brawl and strife
Will fight a Dutchman with a knife;
O that is just the lad for me,
And such is honest six foot three.

His career is continued in the later Norfolk sections of this book.

Charles Dickens (1812–80) travelled to Norwich on New Year's Eve 1848 during a visit to Yarmouth to gain information about the seaside town and area for his new book *David Copperfield*. He had heard talk of the notorious murder of Isaac Jermy, the Norwich Recorder, by James Rush, who had been imprisoned in the castle gaol and hanged at the traditional place of execution at the foot of the bridge outside the gaol walls. Dickens went to look at the site and declared it 'fit for a gigantic scoundrel's exit'. He also went to have a look at Stanfield Hall, in Wymondham, where the murder had taken place.

28

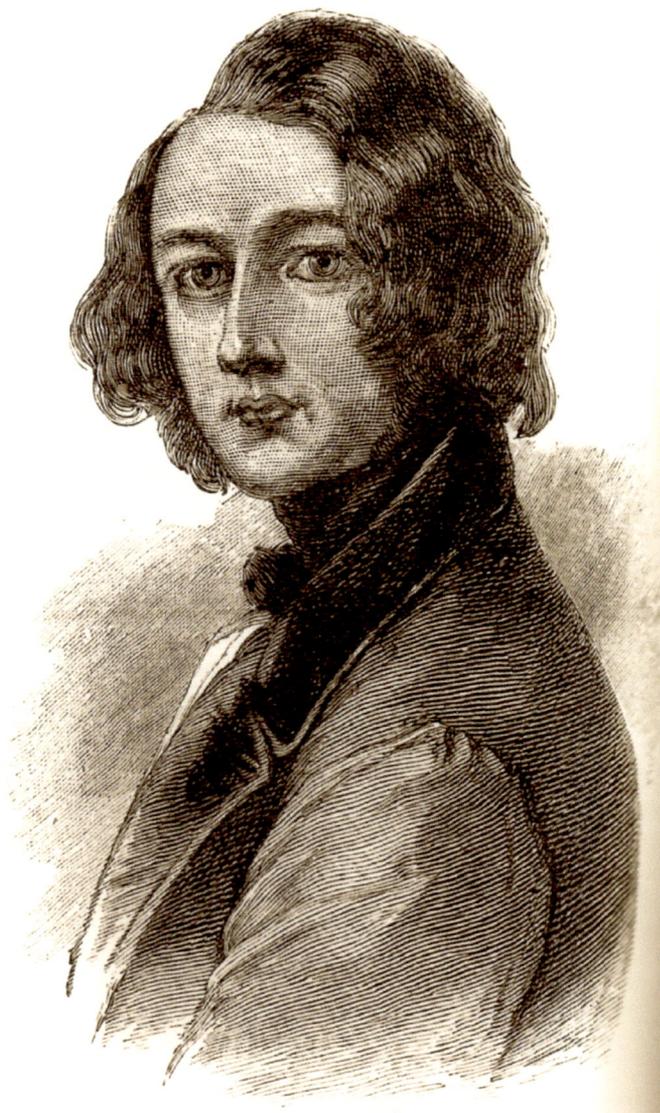

Charles Dickens.

L. P. Hartley (Leslie Poles Hartley, 1895–1972) was born near Peterborough, educated at Harrow, London, and Balliol College, Oxford. He spent most of his youth in the family residence at Fletton Tower near Peterborough, and while in the Norfolk area regularly visited the small seaside resort of Hunstanton in north-east Norfolk, which features as Anchorstone in the opening chapters of his finest and most critically acclaimed trio of novels *The Shrimp and the Anemone*.

The Go-Between (1953) is his most popular novel, and some scenes in it are set in Norwich. The lead character, thirteen-year-old Leo, lunches with Marian, with whom he is smitten, at the ancient Maid's Head Hotel in Wensum Street, Tombland near the entrance to the cathedral, and after lunch he wanders in the cathedral precincts where he cranes his neck 'trying to fix the exact point at which the summit of the

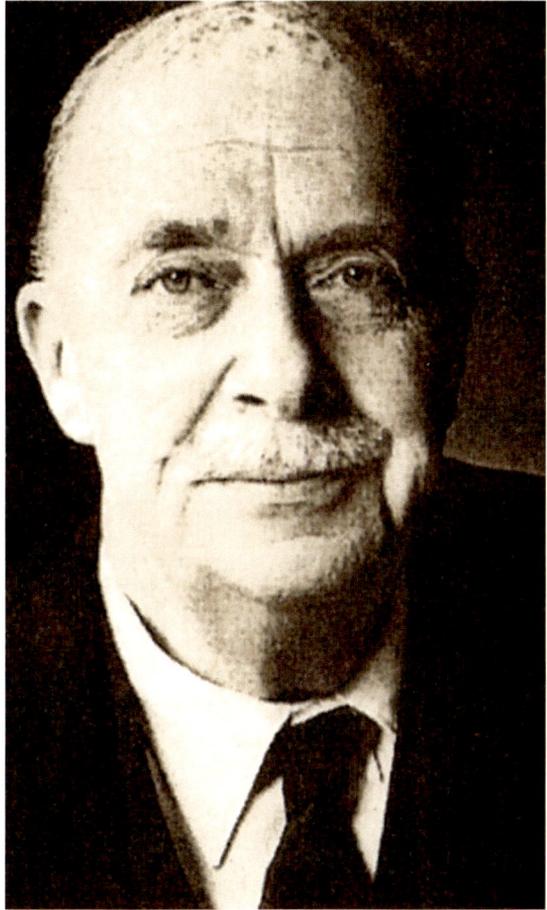

L. P. Hartley.

spire pierced the sky'. He also wanders in the Hay Hill area close to the market, where he waits near the statue of Sir Thomas Browne for Marian to meet him, unaware that the purpose of their visit to Norwich – ostensibly to buy him a light summer suit – was to give her the opportunity to meet her farmer lover Ted Burgess. Burgess is from a completely different social class to Marian, which leads to the tragic denouement of the sensitive and tenderly handled theme, and Leo's rude awakening and lifelong remorse.

Sir Malcolm Bradbury (1932–2000) was a novelist, literary critic and writer of TV plays. He was born in Sheffield, attended grammar school in Nottingham, and studied English at Leicester University. He held various academic roles tutoring in literature, and wrote several novels including *Eating People Is Wrong* (1959) and the popular *The History Man* (1975), set in an academic university milieu and televised as a four-part serial by the BBC in 1981.

In 1970 he was appointed Professor of English and American Studies at the University of East Anglia, Norwich. In the same year, he co-founded an MA degree course in Creative Writing with Sir Angus Wilson, the first course of its kind in Britain.

He was awarded the CBE for his literary achievements in 1991 and was knighted in the New Year's Honours in 2000. He died in Norwich and is buried in St Mary's churchyard, Tasburgh.

Sir Angus Wilson (1913–91) was born in Bexhill-on-Sea and educated at Westminster School and Merton College, Oxford. During a period of military service in the 1940s he had an office post in the Naval Section at Bletchley Park where the demanding role led to a nervous breakdown. A work colleague described him as 'a brilliant young homosexual – He used to mince into the room, wearing in those days, outrageous clothes in all colours; he chain-smoked; his nails were bitten down to the quick, and he had a rather high-pitched hysterical laugh'.

He became a successful novelist with *Hemlock and After* (1952) and *Anglo-Saxon Attitudes* (1956). At the University of East Anglia he was usually seen surrounded by an entourage of adoring young male students who shared his 'gay' personality and interests, and he was highly entertaining and humorous as a conversationalist and lecturer, a vocal brilliance never so effectively conveyed in his novels.

During his lifetime he was acclaimed as Britain's greatest contemporary novelist and praised as an author, 'seldom without compassion, and nevertheless brilliantly satirical and often macabre', gaining the James Tait Black Memorial prize for *The Middle Age of Mrs Eliot* (1958). He was president of the Royal Society of Literature in 1982–88, and was awarded the CBE in 1968 and a knighthood in 1980.

Three writers who were early students and graduates of the Creative Writing course are Ian McEwan, Rose Tremain and Kazuo Ishiguro.

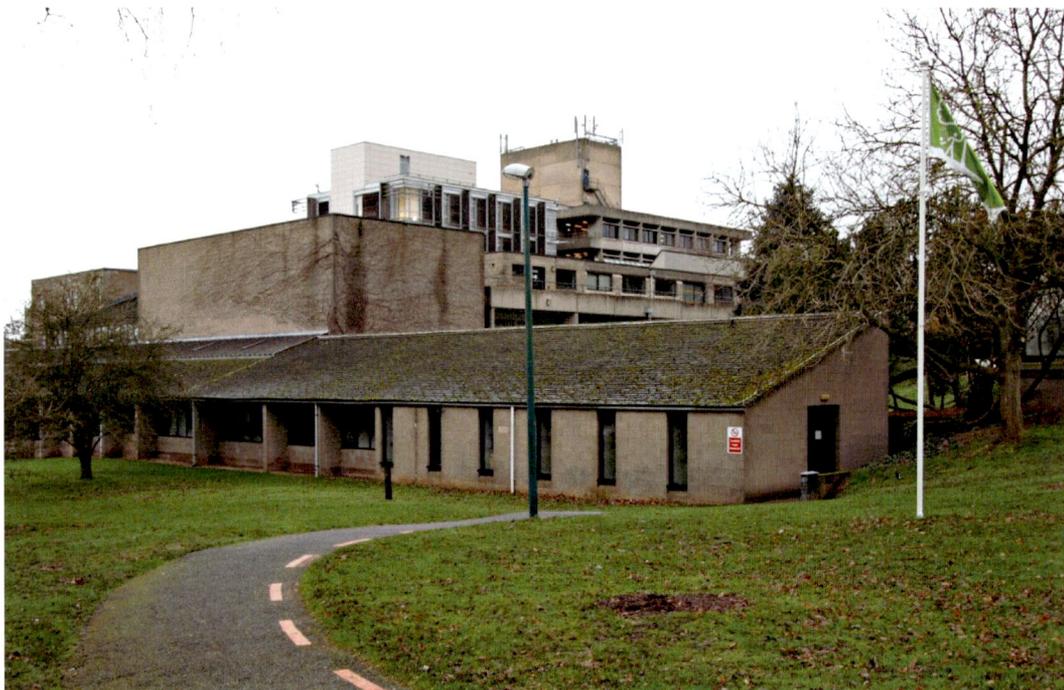

The University of East Anglia.

Ian McEwan was born in 1948 at Aldershot in Hampshire. He enrolled as the first student at the University of East Anglia's School of Creative Writing and graduated with an MA degree in 1971. He was influenced by the American writers Philip Roth and William Burroughs, two novelists who were very influential and popular for literature students when I was working in the UEA bookshop during that period. He compared their 'kind of garishness' to the 'poky and grey world of English fiction dominated in the 1970s by middle-aged, middle-class novelists such as Kingsley Amis and Angus Wilson'. Wilson, the resident lecturer and tutor, must have been peeved if he heard this comment, and McEwan adds that 'to add bold and violent colours became my imperative'.

His first book, a collection of short stories entitled *First Love, Last Rites* (1975), won the Somerset Maugham Award for fiction. With subsequent novels he became increasingly highly acclaimed and was himself described as 'Britain's greatest living novelist'. McEwan has been nominated for several Booker prizes and was awarded the Booker Prize for *Amsterdam*. Many of his novels have been adapted for film or television, most notably *Atonement*.

His novel *The Child in Time* (1987) has a section set in Suffolk, thought to be inspired by Felsham Woodside near Bury St Edmunds where Angus Wilson occupied a cottage for the greater part of his life. Stephen Lewis, the lead character in the novel, visits a friend in the area and is taken by him into the woodland near his house. Here he is invited to shin up an enormous beech tree where Charles has built a wood cabin at the very top. In one of the most compelling incidents of the story, Stephen attempts to follow his friend up, but, suffering from vertigo, he soon starts to panic.

> He passed a minute, calming himself. He decided it would be better to return to the ground. He wanted to please his friend, but it was pointless, after all, risking his life. Here was another problem. To find the foothold below, he had to look down, and his nerve had gone for that. 'Oh, God', he whispered to the tree. 'What am I going to do ?' He did nothing. He strained to hear a comforting sound from the ground. Even birdsong would have done. But up here, there was nothing, not even the wind. It occurred to him, fleetingly, that he was engrossed, fully in the moment. Quite simply, if he allowed another thought to distract him he would fall out of the tree. Then he thought, I don't want to be doing this any more. I want to do something else. Take me out, make this stop.

Eventually he does make it to the top, and collapses, alternating between sobbing and needing to retch. And then, a short while later on, there is the downward descent to be made. Shaking with fear, he crawls towards the platform edge while his friend hoots with laughter and, peering up at Stephen, declares 'Now, do exactly as I tell you, or else you'll die.'

Rose Tremain was born in 1943 in London and had a successful career as a novelist after she graduated from the UEA Creative Writing course for which she subsequently became a tutor from 1988 to 95. Kazuo Ishiguro was one of her students. Her novels include *Music and Silence*, for which she was awarded the Whitbread Novel of the Year. She was

awarded the James Tait Black Memorial Prize for *Sacred Country*. She was made a CBE in 2007. Her most popular novel is perhaps *Restoration* (1989). It describes how a young medical student, Robert Merivel, wins favour with King Charles II and is given Bidnold Manor house in Norfolk on condition he marries the king's mistress, Celia, so suspicions about the king's affair with her are dispersed, but he can still continue to enjoy sexual dalliances with her. Merivel has little interest in the peevish and affronted Celia, who remains obsessed with the king, but he falls in love with the house and its gardens and the Norfolk landscape. When he decides to take up painting as a hobby, his preferred subject becomes the parkland. On 'a splendid autumn morning, burnished by the sun', he carries his painting equipment to a far corner of the south lawn

from which I had a most magnificent perspective of the park – the purple and gold beeches, the russet elms, the fiery chestnuts, and the soft sweep of brown beneath them, that was the line of grazing deer.

I stared at this scene. I knew that to render the foliage of a tree in all its complexity was beyond my skills ... what I could try to capture however, were the colours. Thus without sketching anything ... I began furiously to mix my pigments and to lay the paint on in bold sweeps and flourishes, colour upon colour, a scrabble of white for a cloud, wavering lines of green and yellow for the rich grass, cascades of oranges, reds and golds for the chestnuts... My temperature rose, and my heartbeat quickened. I was ablaze with my painting. I knew that it was as wild, as undisciplined, as excessive as my own character, but it was perfectly expressed, all unskilled as it was, my response to that autumn day, and thus, to me, had a satisfactory logic to it. When it was at last finished, I stepped back and ... (saw) it was perhaps, as if a child had painted it. It was crude. The colours were too bright and too many. And yet, it didn't lie ... it was, in some essential way, what I had seen. I walked round to the back of the canvas, and scribbled a title on it in French: Le Matin de Merivel, l'Automne'.

A most convincing and exhilarating description of the act of creation for an amateur artist by an artist in words.

Rose Tremain – official website www.rosetremain.co.uk.

Kazuo Ishiguro was born in Nagasaki, Japan, in 1954 and moved with his family to Britain in 1960. He was educated at Kent University, graduating in 1978, and then joined the MA Creative Writing course at UEA in 1980. His nine novels have established him as one of Britain's greatest authors, and he has received various honours including the Booker Prize in 1989 for *The Remains of the Day*, an OBE for services to literature in 1995, and the supreme honour of the Nobel Prize for Literature.

The Remains of the Day and *Never Let Me Go* have been made into acclaimed films, and he received a knighthood in 2018 for services to literature.

The Buried Giant (2015) was his first novel for ten years after *Never Let Me Go* and was welcomed with huge acclaim from the media literary critics; the *Financial Times* classed it, with his other novels, as 'among the strangest, most haunting, and affecting in contemporary literature'. The narrative is set in the Britain of around 1,500 years ago, in the period after the Romans had returned to defend their own homeland in the early fifth century and increasing numbers of Saxon tribes were invading from the Continent. It's a period that remains a mystery to historians and a subject of archaeological investigation and legend. The Saxons are in control of Eastern England, while other parts are still dominated by the Britains, and notably in the wake of the influence and achievements of the semi-legendary King Arthur.

I might point out that navigation in open country was something much more difficult in those days, and not just because of the lack of reliable compasses and maps. We did not yet have the hedgerows that so pleasantly divide the countryside today, into field, lane and meadow. A traveller of that time would, often as not, find himself in featureless landscape the view almost identical whichever way he turned. A row of standing stones on the far horizon, a turn of a stream, the particular rise and fall of a valley: such clues were the only means of charting a course.

And the consequences of a wrong turn could often prove fatal. Never mind the possibilities of perishing in bad weather; straying off course meant exposing oneself more than ever to the risks of assailants – human, animal, or supernatural – lurking away from the established roads (built by the Romans).

You might also have noted that whenever the path grew too narrow to walk side by side, it was always Beatrice, not Axl, who went in front.

This too might surprise you, it seeming more natural for the man to go first into potentially hazardous terrain... But for the most part Axl would make sure his wife went first, for the reason that practically every fiend or evil spirit, they were likely to encounter was known to target its prey at the rear of the party ... There were numerous instances of a traveller glancing back to the companion walking behind, only to find the latter vanished without trace. (Chapter two)

Another significant writer connected with UEA is **W. G. Sebald**, who was Professor of Modern German Literature from 1970 until his death in a car crash, aged fifty-seven, in 2001. He was born in Wertach im Allgau, in the Bavarian Alps in 1944 and in 1966 settled in Britain, initially as a lecturer at Manchester University and then moving to UEA. He is remembered as a great teacher as well as a great writer

In *The Rings of Saturn* (1998), which records an explorative foot journey through coastal East Anglia, Sebald writes in the final chapter about the silk industry in Norwich. It became a major and wealthy industry in the early eighteenth century when more than 50,000 Huguenots fled to England to escape persecution in France. Many of them were experienced in the breeding of silkworms and the manufacture of silk fabrics, and by 1750 the Huguenot master weavers of Norwich had risen to become the wealthiest, most influential and cultivated class of entrepreneurs in the entire kingdom.

> In their factories and those of their suppliers there was the greatest imaginable commotion, day in and day out, and it is said ... that a traveller approaching Norwich under the black sky of a winter night would be amazed by the glare over the city, caused by light coming from the windows of the workshops, still busy at this late hour.

Their back-breaking labour caused both physical and mental torture, dealing with the complicated fabric patterns. But the silks they produced,

> brocades and watered tabinets, satins and satinettes, camblets and cheveretts, prunelles, callimancoes, and florentines, diamantines and grenadines, blondines, bombazines, belle-isles and martiniques – were of a truly fabulous variety, and of an iridescent, quite indescribable beauty as if they had been produced by Nature itself, like the plumage of birds.

Many of the fabrics were used to create fashionable black gowns and mantuas for upper-class ladies to express their bereavements during long periods of mourning. Sir Thomas Browne was the son of a silk merchant and remarks in a passage of his *Pseudoxia Epidemica* that it was customary in Holland during his lifetime

> in a home where there had been a death, to drape black mourning ribbons over all the mirrors and all canvasses depicting landscapes or people, or the fruits of the fields, so that the soul, as it left the body would not be distracted on its final journey, either by a reflection of itself or by a last glimpse of the land now being lost for ever.

Sebald achieved the reputation of a major international author and was tipped as a candidate for the Nobel Prize for Literature.

In 2003, Ute Sebald (his widow) and her family organised a commemorative bench placed near the broad stretch of water in the beautiful landscape setting of the university. The bench encircles a copper beech tree. Other trees have been planted by the writer's former students, and the spot is now known as 'Sebald's Copse', an ideal way of commemorating the UEA lecturer who was so greatly respected and loved.

The Norfolk Broads

This area is low-lying with surface drainage, situated in the areas near Norwich, and the upper parts of the Yare and Bure river valleys. The wide swathes of water are fringed

with reeds and alders, and the areas near Great Yarmouth and the Waveney Valley are characterised by grazing marshes – but for cattle not sheep. The towers of the historic drainage mills still add a distinctive element to the landscape. The Broads from Beccles to Great Yarmouth are very popular with tourists who hire motor-boats and cruisers, which add a colourful and picturesque aspect to these regions, especially in the summer months.

Apart from Norwich, **George Borrow** is mostly associated in Norfolk with Oulton Broad. He married Mary Clarke in 1840 and they settled (if that can ever be truly said of Borrow) at her house Oulton Cottage, isolated by the waterside, with her daughter from a previous marriage. In the summer house in the garden, which he used as his study, he wrote *The Bible in Spain* (1843), describing his employment with the British and Foreign Bible Society and his travels there, and *Lavengro* (1851). Having completed a book, he would often say to Mary, 'Beloved – today is a day to go walking', and then disappear, not returning until several months later, nonchalantly remarking as he strolled in through the gate, 'Beloved – a fine walk !'.

Mary died in 1869 and he was lonely without her, as his beloved mother had died in 1858, and Mary had been like a second mother to him. Having spent a period living in London, he returned to the house in Oulton Broad, in 1874, where he died alone in 1881. He was buried with Mary in Brompton Cemetery, Kensington, but there is a memorial to him in the Oulton church. Later the Oulton house was demolished, but his writing summer house still survives.

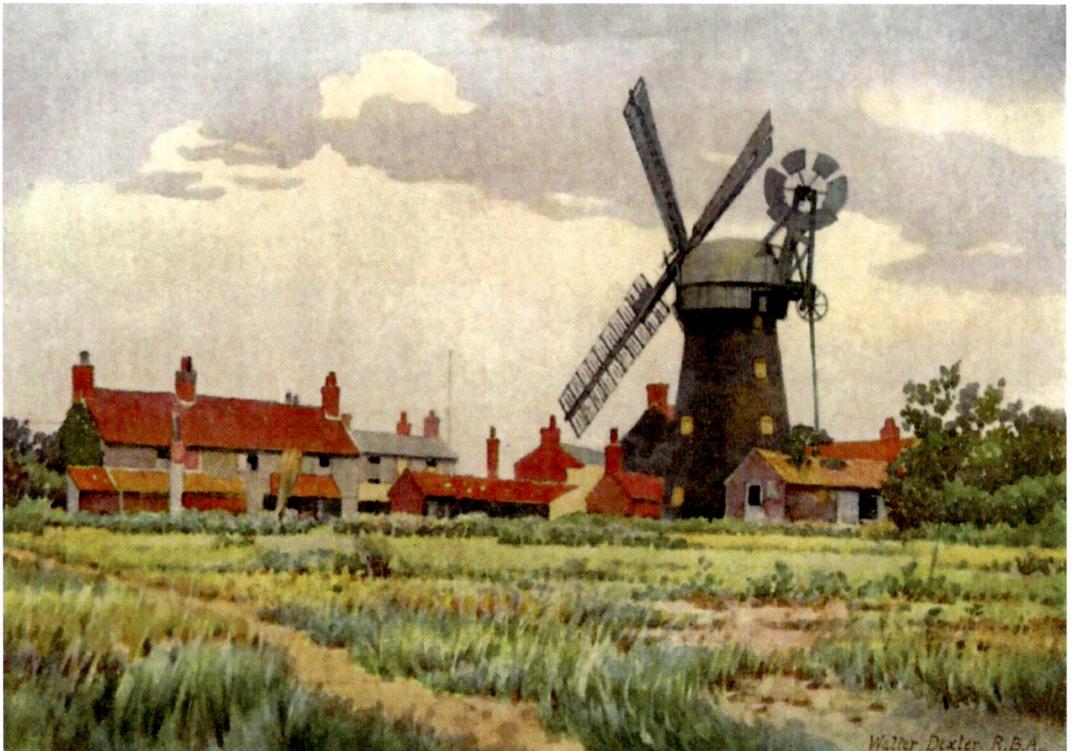

Blundeston, watercolour by Walter Dexter, *Some Literary Associations of East Anglia*, W. A. Dutt, 1907.

Great Yarmouth is the major seaside resort on the Norfolk coast. It is a long, narrow town, and its prosperity resulted in medieval times from its herring industry, so important to its economy that herrings appear on the town's coat of arms. In recent years the herring trade has greatly declined, and Yarmouth's importance now depends on its very busy port and it's increasingly prosperous tourist industry. The town centre has an interesting array of historic features, including St Nicholas Church, the largest parish church in England, in the eighteenth century Fishermens' Hospital, the lofty Nelson monument surmounted by a figure of Britannia, the old Tollhouse (now a popular museum), and some of the medieval defensive walls still survive.

Charles Dickens came to Great Yarmouth in 1849 to gain inspiration for his new partly autobiographical novel *David Copperfield*, published a year later. He stayed at the Royal Hotel on Marine Parade, and his first impression of the region was that it was 'the strangest place in the world'. Blundeston, a little village south of Yarmouth, becomes David Copperfield's birthplace. Dickens had taken a long walk in that direction – Yarmouth to Lowestoft and back again, 23 miles – and was struck by the unusual name on the milestone that he noticed en route, so Blundeston becomes 'Blunderstone'. Copperfield's impressions of Yarmouth are recorded as 'rather spongy and soppy, I thought, as I carried my eye over the great dull waste that lay across the river; and I could not help wondering, if the world was really as round as my geography book said, how any part of it came to be so flat'. In Yarmouth David is brought up by his mother and Peggotty, his nanny, married to a local fisherman, who is proud to call herself 'a Yarmouth bloater'.

It's horrifying to think how horses, such intelligent, noble creatures, have been abused and exploited over the centuries, treated as a means of transport, with little regard for their welfare, and often extreme cruelty: 'flogging a dead horse', epitomises the inhumane attitudes that prevailed. **Anna Sewell** (1820–78) must be applauded for writing the novel which sought to promote more sensitive treatment: *Black Beauty: His Grooms and Companions – The Autobiography of a Horse, translated from the original equine* (1877).

Engraving of Peggotty's beach house, Great Yarmouth, by 'Phiz'. (© The Dickens House Museum, London)

The house, centre, occupied by Anna Sewell, near St Nicholas Church, Great Yarmouth.

Sewell was born in Great Yarmouth in 1820, in a quaint half-timbered house on Priory Green abutting St Nicholas churchyard. She was influenced by reading Horace Bushell's *An Essay on Animals*, which advocated greater compassion, and her story was aimed at gaining the interest of children, to instil a caring attitude from an early age. The suffering at the hands of humans, narrated from the horse's point of view, gives an immediacy and depth of feeling to enlist the reader's sympathy.

Sewell had moved with her parents to Old Catton, near Norwich, in 1866, and it's where she wrote her book while she was confined to bed for most of her life due to an unidentified illness. She only lived for a year after the book was published, so never really enjoyed its phenomenal success, becoming a well-deserved perennial classic which has now sold over 50 million copies.

In November 2022, the Sewell house in Great Yarmouth opened as a museum, managed by the Redwings horse rescue sanctuary in Norfolk. So a very appropriate ownership, and they can promote the welfare of horses there to a wider public.

Winterton, a bit further along the Norfolk coast from Yarmouth, was visited by **Daniel Defoe** (1660–1731), as described in his three-volume *Tour Through the Whole Island of Great Britain* (1724–27). He was writing his most famous book, *Robinson Crusoe* (1720), applauded as 'the first English novel of genius', and describes how the character is shipwrecked near Yarmouth, and he and the crew are rescued in a lifeboat and pull

towards the shore near the Winterton lighthouse. When he is on dry land, Crusoe walks to Yarmouth where he gets overnight accommodation, and his real adventures begin when he then travels to London and boards a ship for Africa.

The small seaside town of Mundesley has connections with the poet and hymn-writer **William Cowper** (1731–1800). He was born in Berkhampstead and educated at Westminster School and subsequently adopted a career in the legal profession at the Middle Temple, London. A period of mental instability resulted in his being committed to an asylum in St Albans in 1763–65. On recovery his brother John found him accommodation in the small quiet town of Huntingdon. There he was befriended by the Reverend William Unwin and his wife, Mary. Mrs Unwin made a particular friend of him, and she helped to restore Cowper's mental health. When William Unwin was killed as a result of a riding accident, Mary and Cowper moved to Olney in Buckinghamshire, and there Cowper formed a friendship with the Evangelical Olney curate the Reverend John Newton. Newton encouraged Cowper to compose hymns for a hymn book he was compiling, and this congenial occupation also did much to help restore Cowper's spirits. Several of his hymns are still sung in churches today, including 'Hark! My Soul It Is the Lord', and 'God Moves in a Mysterious Way, His Wonders to perform'. The two popular hymns 'Glorious Things of Thee are Spoken' and 'How Sweet the Name of Jesus Sounds' are attributed to both Newton and Cowper, so presumably were a collaboration.

Writing hymns gave Cowper confidence to also write poetry and his *Collected Poems* were published in 1782 and include the popular and lively ballad tale of 'John Gilpin'. His major long poem 'The Task' was published in 1785, containing beautiful descriptions of his love for nature and the local landscape. He is considered the finest poet of nature prior to Wordsworth.

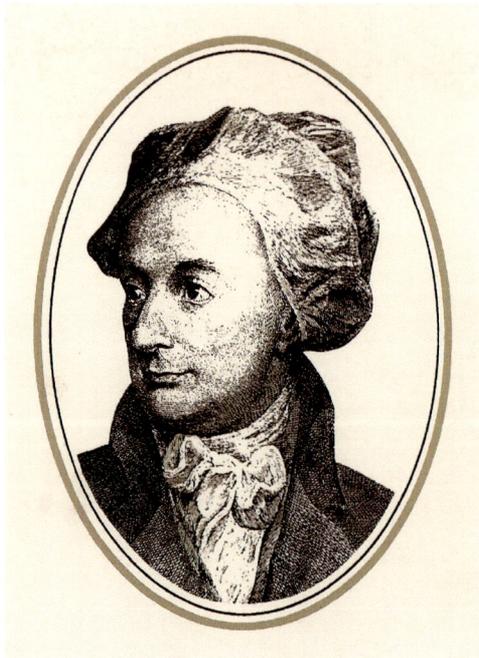

William Cowper – engraved cameo portrait.

In 1795 Cowper spent a period staying with his cousin the Reverend John Johnston in the High Street of the small coastal town of Mundesley. Johnston was a cheerful character and his amiable company greatly lifted Cowper's depressed spirits. Cowper went for walks along the beach and into the countryside, and in a letter he identifies himself with a large solitary pillar of rock by the cliffs: 'I have visited it twice, and found it an emblem of myself. Torn from my natural connections, I stand alone, and expect that the storm shall displace me.' He continued to visit the resort throughout the remaining years of his life, and this part of the Norfolk coast, including Happisburgh, continues to be increasingly threatened by the encroaching tides in severe weather, causing parts of the cliffs to collapse. More information about Cowper can be found in the East Dereham section.

Captain Frederick Marryat (1792–1848) was born in London, the son of an MP. He entered the Navy when he was fourteen, and having spent a period in the West Indies, was involved with guarding the Emperor Napoleon from escape while he was exiled on the island of St Helena. He was also involved with the suppression of the smuggling trade in the English Channel.

He retired from the Navy by 1828 and resolved to become a writer. Not surprisingly, his initial theme as a novelist was sea-life. In quick succession he published *Frank Mildmay* (1829), *Peter Simple* (1833), and *Jacob Faithful* (1834), and one of his most popular tales, *Mr Midshipman Easy*, was published in the same year. His marriage resulted in eleven children, and they moved to Manor Farm, a thatched Tudor house on the Cocksthorpe

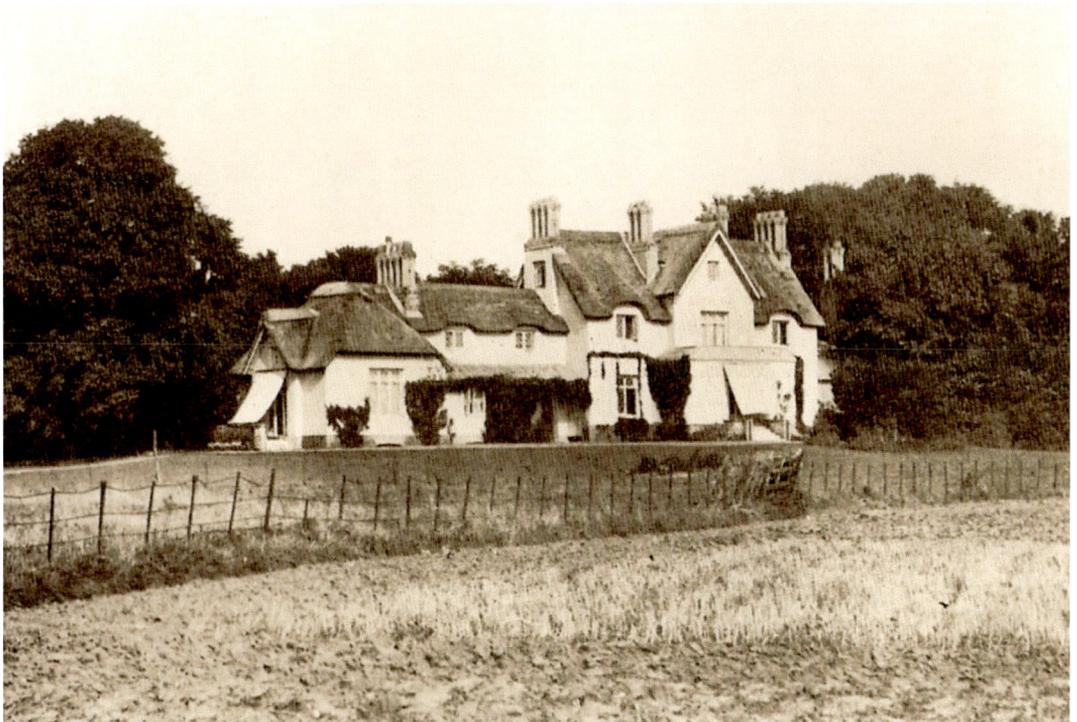

The Manor Cottage, Langham, home of Captain Marryat.

Road at Langham near Cromer, in 1843. The farmhouse was demolished following his death, but Manor Cottage was built on the site. There he wrote his best-loved story for children, *Children of the New Forest* (1847). Set in the period of the Civil Wars, it deals with the adventures of four children from an aristocratic family who supported the Royalist cause and their escapades seeking to escape detection from Cromwell's troops.

Marryat was buried in the churchyard of St Andrew and St Mary's, in 1848, where there is a handsome marble tomb, and a marble memorial in the church on the wall of the nave.

Gresham's School, in the small market town of Holt, was where the poet **Wystan Hugh Auden** (1907–73), born in York, was educated, enrolling in 1920. He is considered the major poet of the first half of the twentieth century other than T. S. Eliot, and an immense literary influence on other writers. His education is his only connection with East Anglia and he condemned the school as 'a Fascist state'.

But he did well academically, won a scholarship, and gained praise for his English essays. He also enjoyed the opportunities he got to explore the local countryside, with its nearby coast between Sheringham and Wells, and broad swathes of salt marshes where he could stroll and meditate in the serene wide-skied atmosphere and compose poems in his head. His time there resulted in the ambition to be a poet, as a late verse expresses, prompted by a fellow pupil Robert Medley:

> Kicking a little stone, he turned to me
> And said 'Tell me, do you write poetry ?'
> I never had, and said so, but I knew
> That very moment what I wished to do.

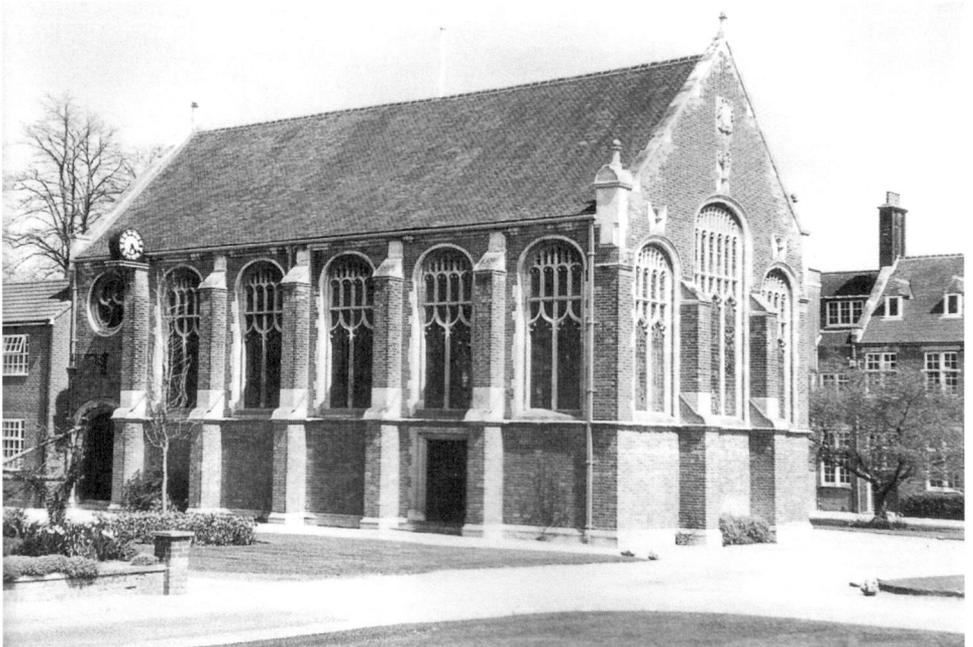

Gresham's School Holt, where the poet W. H. Auden was educated.

Auden also enjoyed performing in the school plays, playing Katherina in *The Taming of the Shrew* (1922), and was recalled by a fellow pupil as: 'A small slightly puffy little boy, with pink and white cheeks and almost colourless hair, not very good at being a girl, red wrists projecting from frilly sleeves, and never knowing what to do with his hands. His voice however was clear and his diction excellent.'

Later in his career he also acknowledged the Diss poet John Skelton as a literary influence. His first volume of poetry, simply entitled *Poems*, was accepted for publication by T. S. Eliot for Faber in 1930, and from then on his literary reputation was assured.

Henry Williamson (1895–1977) is associated with the little town of Stiffkey near Wells on the Norfolk coast. He was born in Brockley, south-east London (some say Bedfordshire), and developed a deep love of nature, exploring the Kent countryside and reading the rural-themed books of Richard Jeffries.

Following war service, he lived for a time in Georgeham, Devon, where he lived a rough life more or less a hermit, sleeping out at night, collecting a menagerie of birds and animals – he rescued an otter cub whose mother had been shot by a farmer, and it became the subject of his best-loved book *Tarka the Otter*. He married in Devon and had six children.

Visiting his publisher at East Runton near the Norfolk coast in 1936, he viewed the Old Hall Farm near Stiffkey, which had 235 acres, and took a fancy towards pursuing a farming way of life. He was already a best-selling author: *Tarka the Otter* had won the Hawthornden Prize in 1928 and *Salar the Salmon* was a success published in 1935. It couldn't have been a worse time to take up farming as the Second World War was soon underway, and the country was suffering from an agricultural recession. But he felt that farming was an honourable and vital way to serve the country and would provide a safe haven for his family, and in particular his son wouldn't have to enlist, as farming was a reserved occupation.

The farm estate was in a poor way when he took it on, and his struggles and set-backs are recorded in *The Story of a Norfolk Farm* (1941).

Henry Williamson, who farmed at Stiffkey, near the Norfolk coast.

He was successful in converting the farmhouse into a comfortable home and making his land productive, but it was tough and unceasing labour.

He became increasingly overstrained and disillusioned, partly resulting in the break-up of his marriage, so in 1945, as war drew to a close, he sold up and moved to Botesdale, near Diss. Then he moved back to Devon and became a prolific author, from 1951 to 65 writing virtually a book a year, sometimes writing for fifteen hours a day. The *Chronicles of Ancient Sunlight* is his major achievement, and his Norfolk farming experiences are featured in some of his novels. It was said of him that, 'He strove always to illuminate a scene or incident with what he considered sunlight, and he sought to see the world as the sun sees it, without shadows.' Regarded as one of Britain's most gifted nature writers, he involved his readers by writing from his creatures own viewpoints and focusing on 'the eternal struggle of living things to survive, and a deep awareness of the transitory fragility of their lives'.

The Victorian seaside resort of Hunstanton, on the Norfolk coast, was well known to **L. P. Hartley** when his family were living in the fens area, and it features as Anchorstone in his novel *The Shrimp and the Anemone*, the first of his trilogy of novels (1944–47) featuring brother and sister Eustace and Hilda who move there with their family. Hartley vividly recreates the Edwardian seaside atmosphere where the children spend much time playing on the beach and where Eustace is impressed by the Jacobean mansion Anchorstone Hall (Hunstanton Hall). Viewing it one evening as dusk falls and it is

Hunstanton Hall, North Norfolk. (Courtesy of Peter Tolhurst, *East Anglia, A Literary Pilgrimage*, Black Dog Books, 1996)

illuminated by moonlight, he exclaims, 'Oh, isn't it lovely? If I ever made enough money to buy it, will you come and live with me there, Hilda?' He becomes friends with Dick, the son and heir of the Stavely family who live there, and his romantic love for both Dick and the hall result in machinations to get Dick and Hilda engaged, with shocking consequences, resulting in the tragic climax to the novel.

King's Lynn, near the Norfolk coast on the River Ouse, was already a port and market town when Herbert de Losinga, first Bishop of Norwich, founded a priory there soon after the Norman Conquest and built St Margaret's Church. Apart from the fine medieval churches and monastic remains, the town also has some distinguished merchants houses. The Saturday Market place has the Trinity Guildhall with a beautiful chequered stone façade and the twelfth-century St Margaret's Church. A serious fire occurred in this region in 1421: the Guildhall was destroyed and later rebuilt, and St Margaret's was at risk too. But **Margery Kempe** (*c.* 1373–*c.* 1440), a mystic, persuaded her confessor to remove the Blessed Sacrament from the church for safety, and shortly afterwards, heavy snow and rain began to fall which quenched the flames.

Margery was born in King's Lynn. Her father, a prosperous merchant, became mayor of the town and an MP. She married John Kempe, a town official, in 1394, and they had fourteen children. Following the birth of her first child, she experienced nightmares of demons attacking her and trying to intimidate her to renounce her religious faith. She then began to experience religious visions, which included conversations with both God the Father and Jesus Christ, and which included the marvellous experiences of being present at both Christ's Nativity and Crucifixion. Like most women of her period she had no education, but a priest read to her from basic books of religious devotion, and she learned some of the basic texts of the Catholic faith. From the period when the visions commenced she attended Confession three times a day, and wore a hair-shirt as a form of penance. Her religious fervour was so intense that during church services she would wail, sob and suffer extreme bodily contortions, to the upset and annoyance of other members of the congregation, who became threatening and abusive.

So they must have been heartily relieved when her faith persuaded her that she must undertake pilgrimages to sacred sites in both Europe and the Holy Land. She visited Jerusalem and Bethlehem, then Rome and Assisi, and took the pilgrims' path to Compostela in Spain – unique and challenging experiences for a woman of her period.

In around 1413, she visited Julian of Norwich in her church cell, and stayed, sleeping in the church, for several days, conversing and sharing religious experiences with her fellow Mystic.

Margery commenced her account of her visions in the 1430s, dictating them to one of her sons, and then continued by a priest. Completed by 1438, it was titled simply *The Booke of Margery Kempe* and was thought to be the first autobiography by a woman in English. Apart from the miraculous visions, it provides the best insight into the female middle-class experience in the medieval period. It also reveals the tensions between the new Bible-based view of Christianity, Lollardy, as opposed to the Papal and priestly control of religion by the Catholic Church.

Following her death, her book was only known from excerpts compiled by Wynkyn de Worde, in *c.* 1501. In 1934, a manuscript of it was discovered now housed in the British Library and published by the Early English Text Society in 1940.

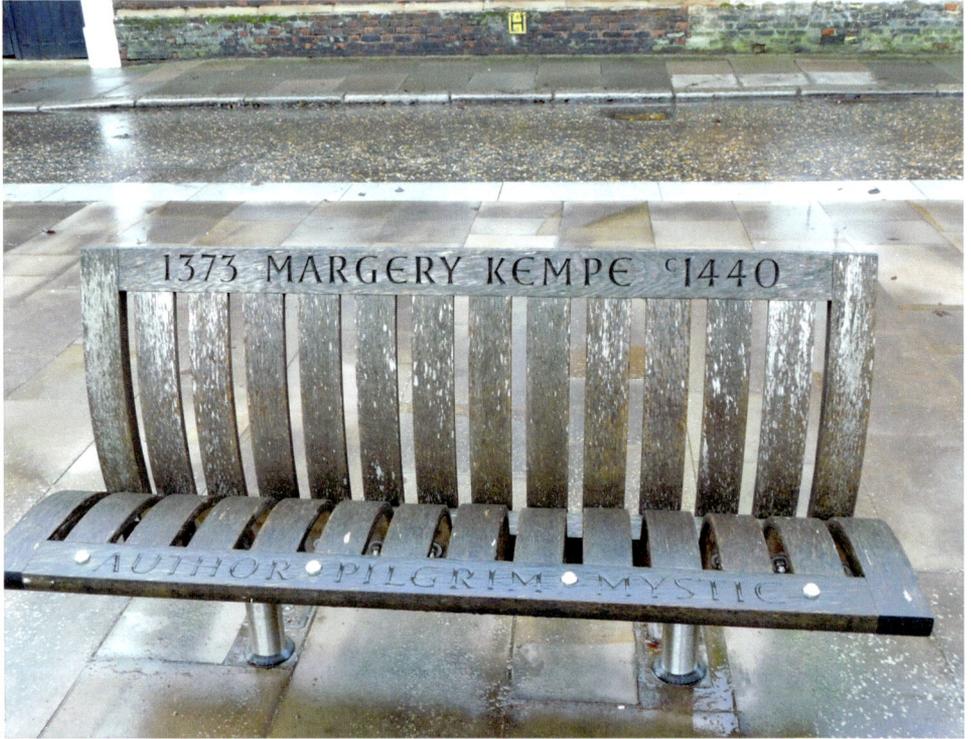

Bench in King's Lynn, Saturday Market Place, commemorating Margery Kempe. (Photo: Martin Reeve)

In King's Lynn, a public bench commemorating Margery was installed in the Saturday Market Square in 2018.

Fanny Burney (1752–1840) was born in King's Lynn, at 84 High Street in a house later rebuilt. Her father was a musician and organist at St Margaret's Church.

Fanny lived and was educated in London in 1770–74, but spent holiday's with her stepmother at the Dower House, near the church, and occupied a little cabin in the garden where she commenced her early career as an author. The cabin was close to the river, and Fanny records in her *Diary* that the damp air or the noise and loud oaths of the watermen sometimes caused her to hastily withdraw into the house.

She also records, in 1768, the pleasures of the local countryside:

for some time past, I have taken a walk in the fields near Lynn, of about an hour every morning before breakfast – I have never yet got out before six, and never after seven. The fields are, in my eyes, particularly charming at that time in the morning – the sun is warm and not sultry – and there is scarce a soul to be seen.

She was staying with family friends at Chessington Hall, south-west London, when Mrs Thrale reported Dr Johnson's praise of *Evelina*, published in 1778, and Fanny was so enraptured that she ran into the garden and danced around the mulberry tree. He

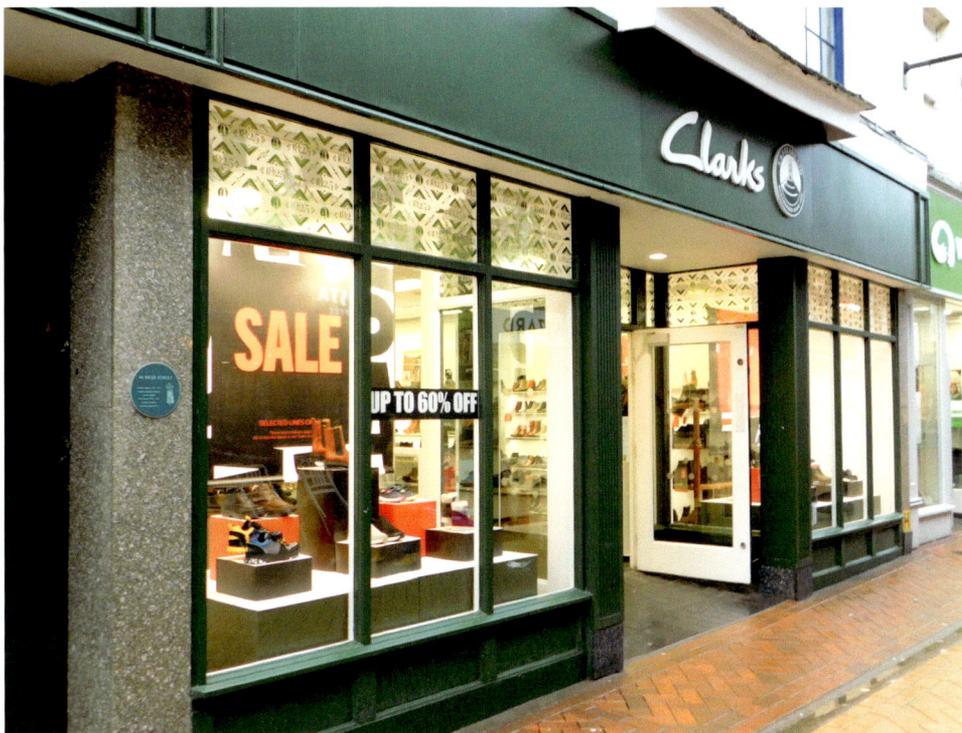

House in King's Lynn High Street occupied by Fanny Burney and her family, now Clarks shoe shop. (Photo: Martin Reeve)

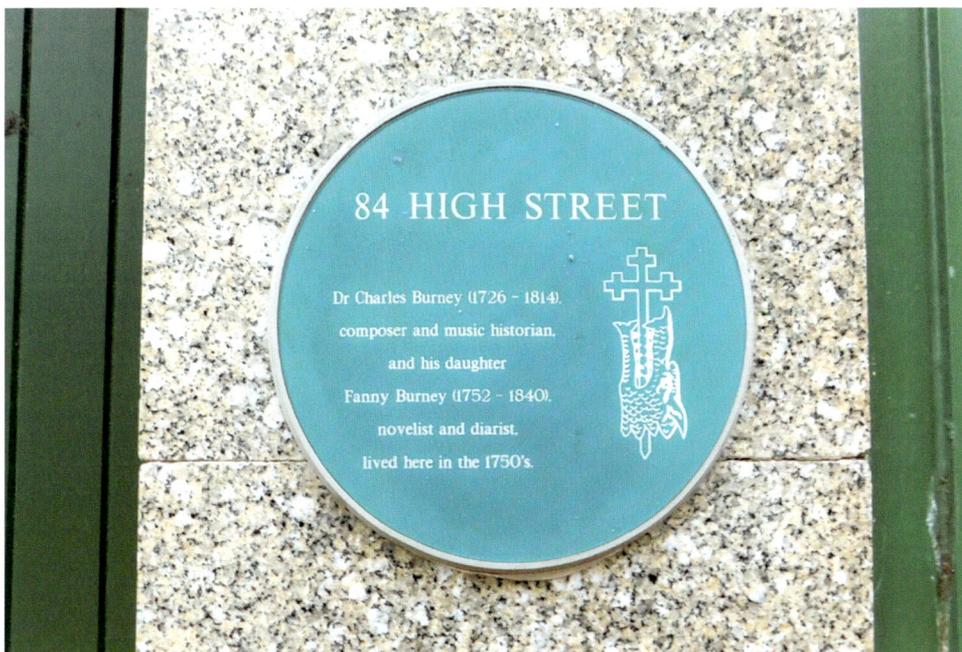

Plaque on the house commemorating Fanny Burney's residence in King's Lynn.

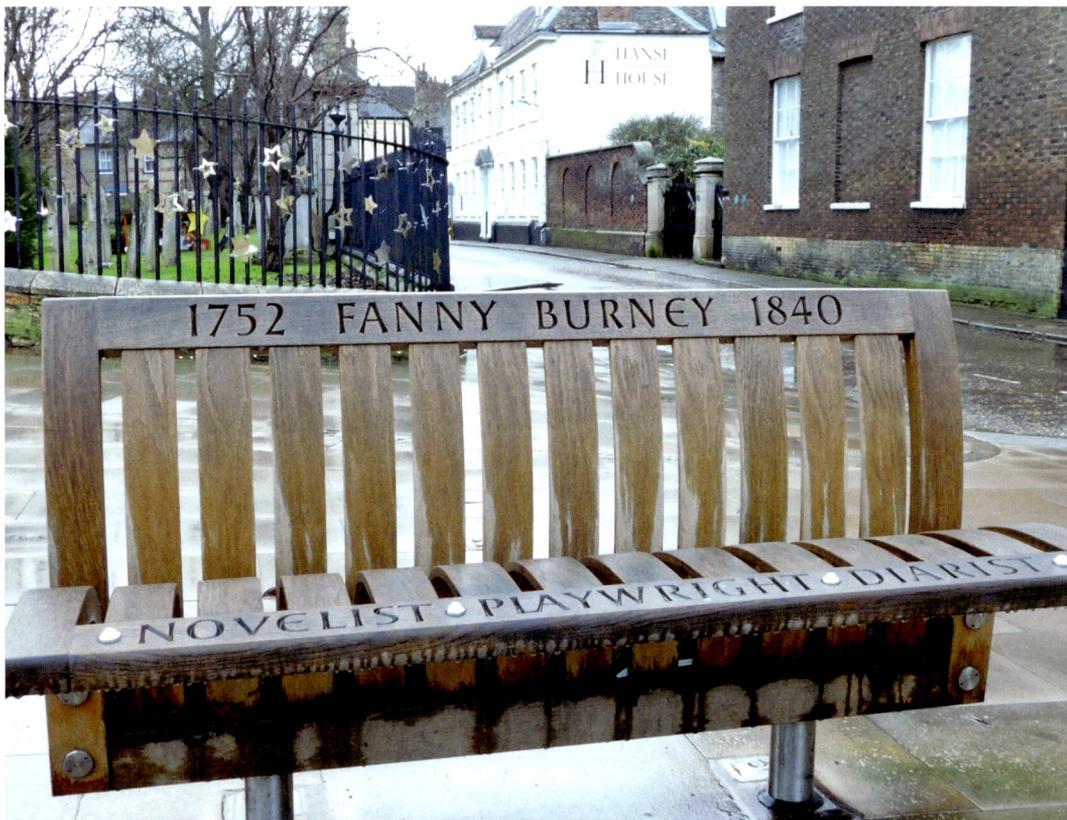

Bench in King's Lynn, Saturday Market, commemorating Fanny Burney.

became a firm friend and promoter of her writing career and termed her his 'little character-monger'.

The novel portrays the experiences and embarrassments of a country girl entering into fashionable London life and society, in a comical and entertaining style, but it seems that it was commenced in her little Norfolk writing cabin. On her fifteenth birthday she impetuously decided that her 'scribbling' was a waste of time, so burnt all her early literary efforts, including an early draft of *Evelina*, but she was able to recall it sufficiently to turn it into her first and finest work: the first English novel of domestic life and a precursor of Jane Austen.

There is a bench commemorating her in the Saturday Market place in King's Lynn.

In the Heartland of Norfolk is Weston Longville, the residence of **Parson James Woodforde** (1740–1803), born in Ansford, Somerset, and appointed Rector in 1776. His celebrated *Diaries* were commenced when he was an undergraduate at Oxford in 1758, and he continued it for forty-three years until his death. Passed down in the family, it was not known until extracts were published in 1924, selected and edited by John Beresford, when it immediately captivated the reading public. Subsequently the Parson Woodforde Society has issued the unexpurgated edition in instalments, commenced in *c.* 1990.

Leading an uneventful life, unmarried, and conscientiously devoted to his parish responsibilities, it is the simplicity of the *Diaries* and the fascinating descriptions of domestic and social life of the Georgian period which have made it popular. In his edition, Beresford delights in highlighting Woodforde's meals and the relish with which he describes them.

A typical dinner meal at the Rectory on 20 November 1882 consisted of 'one fowl, boiled, and Pigg's face, a couple of Rabbits smothered in onions, a piece of roast beef, and some Grape Tarts'. Dining with wealthy friends Mr and Mrs Custance, on 5 June 1784, the 'very genteel dinner' comprised 'Soles and Lobster Sauce, Spring Chicken boiled and a Tongue, a Piece of Roast Beef, Soup, a Fillet of Veal roasted, with Morells and Truffles, and Pigon Pye for the first Course – Sweetbreads, a green Goose, and Peas, Apricot Pye, Cheesecakes, Stewed Mushrooms and Trifle'. It seems a very odd menu to us today, soup served in between meat dishes, not as a starter, and stewed mushrooms between the pudding courses of cheese, cakes and trifle!

Young men sowing their 'wild oats' before marriage was always a problem in the periods before effective contraception became available in the twentieth century. Woodforde provided a home at the Rectory for his nephew William, known as Bill, born in 1758, when he was twenty. Apart from the occasional problems of Woodforde's serving maids becoming pregnant by lads in the village, and having to be discharged, Bill seems to have seduced one of them, named Sukey, and a great favourite with the Parson.

Parson James Woodforde – portrait by his nephew, Samuel Woodforde, R. A. (Courtesy of the Parson Woodforde Society)

This revelation was only comparatively recently discovered in the *Diaries* and revealed in Roy Winstanley's biography (1996), because several of the entries relating to Bill's bad behaviour had been heavily scored over in black ink. But part of one entry in May 1777 has been deciphered as, 'Bill was up in the Maid's Room this morning and Sukey was still in bed – I think there is an intimacy between them.' It therefore seems that, following Woodforde's death, when Bill inherited the *Diaries*, he discovered these revelations and scored them out, not wishing to appear in a tainted character to existing and future relatives who might read them. He could never have foreseen that his sexual peccadillos would be revealed to the amusement of countless numbers of readers of the celebrated *Diaries*.

In 1796, William Cowper was brought by his cousin from Mundesley to live at East Dereham with Mary Unwin. They occupied a red-brick house in the Market Place, and later in the nineteenth century it was replaced by the Cowper Memorial Congregational Chapel. Cowper continued to suffer periods of acute depression and nightmares, partly caused by the conviction that according to the Evangelical religion he was not one of God's elect, and was therefore pre-destined to suffer the pains of Hell Fire when he died. It was during this period that he wrote one of his best-known and most heart-rending poems, 'The Castaway', in which he likens himself to a man fallen from a ship and drowning:

But I beneath a rougher sea,
 And whelmed in deeper gulfs than he.

Mrs Unwin suffered a series of strokes and died in 1796, leaving Cowper heartbroken and bereft. One cure he attempted to ease his acute mental suffering was to take a daily drink from the ancient well near the west door of St Withburga's Church, the water believed to contain medicinal virtues. Following his death in 1800, he was buried in the East Dereham church, and there is a beautiful memorial stained-glass window in the chapel of St Thomas depicting him with his two pet hares.

Bradenham Hall, not far from East Dereham, was where the Ditchingham author Sir Henry Rider Haggard was born, and it also features in the best-loved novel by L. P. Hartley, *The Go-Between* (1954). Hartley stayed there in the summer of 1909, as a guest of his school friend Moxey, and the hall and the wealthy upper-class family, the Maudsley's, who occupy it are brought vividly to life in the novel; the house is named Brandham Hall. Young Leo Colston gets drawn into acting as a go-between conveying messages and letters between the beautiful Marion Maudsley and tenant farmer Ted Burgess with whom she is having a secret passionate sexual relationship. Leo becomes more and more traumatised with his difficult role, and engineers a situation which causes Mrs Maudsley to force him to reveal his knowledge of the affair, and drags the frightened child to a barn where the couple are discovered making love, the revelation resulting in Ted's suicide and Leo's prolonged nervous breakdown. The novel was screened by director Joseph Losey in 1970, his best-known film and a sensational box-office success, premiered in Norwich.

Poet **George Barker** (1913–91), together with his partner and the mother of five of his children, Elspeth Langlands, rented Bintry House, a seventeenth-century farmhouse

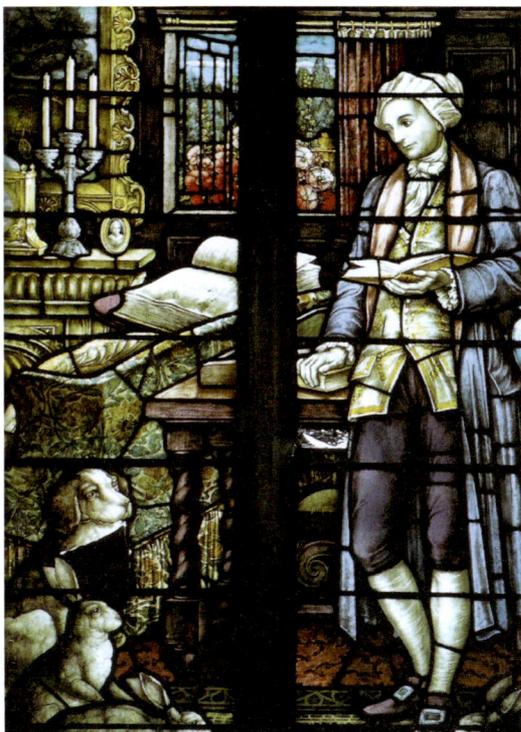

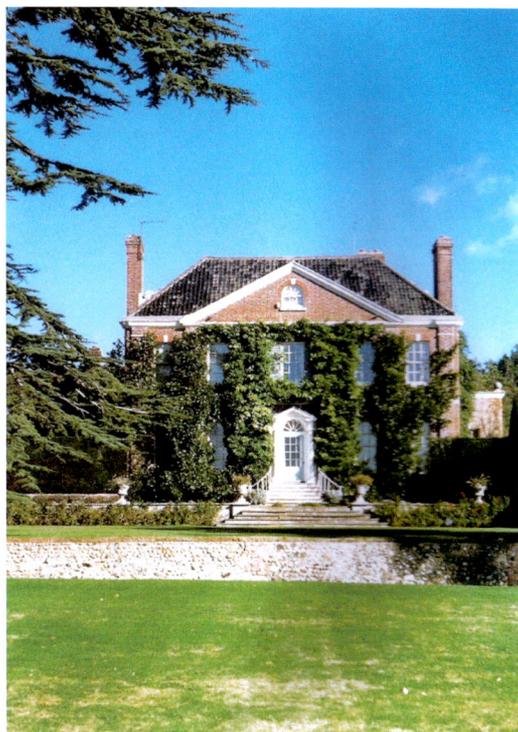

Above left: Stained-glass window commemorating William Cowper, in St Nicholas Church, East Dereham.

Above right: Bradenham Hall. (Photo courtesy of Peter Tolhurst, *East Anglia, A Literary Pilgrimage*, 1996)

owned by the National Trust in Itteringham, near Aylsham, North Norfolk in the 1960s, and occupied it for the remainder of his life. Born in Loughton, Essex, he had little formal education, but was determined to be a poet from the age of sixteen. His second volume of poetry, entitled simply *Poems*, was published by T. S. Eliot for Faber in 1935, and with Eliot's seal of approval, it was an immediate success. Eliot also obtained him a teaching post at Tohoku University in Japan in 1939, and later, lecturing in the States, his long and passionate relationship with Elizabeth Smart developed.

He had early on developed a reputation as a wild Bohemian, frequenting pubs and parties in London's Soho. He was fond of alcohol and drugs, which he took to excess, and organised wild parties at Bintry House. He had a reputation for aggressive behaviour and liked to intimidate people, so when I, as a shy, spotty, young twenty-something, was invited by a friend of his wife, Elspeth, to visit him at Bintry House, I told her I was terrified at the prospect. She responded nonchantly, 'O, no worries! Just talk to him about the British Saints, you're so interested in, and he'll love you!' In fact I needn't have worried; he was well tanked up with alcohol by the time we arrived and had far more attractive and confident people to occupy his attention than me. So I receded into a shadowy corner, and studied him from a safe and admiring distance.

George Barker. (© Christopher Barker)

He wrote various poems about his love of his home landscape, including 'At Thurgarton Church' (1969).

At Thurgarton Church the sun
burns the winter clouds over
the gaunt Danish stone
and thatched reeds that cover
the barest chapel I know.

…I enter and find I stand
in a great barn, bleak and bare.
Like ice the winter ghosts and
the white walls gleam and flare
and flame as the sun drops low.

And I see, then, that slowly
the December day has gone.
I stand in silence, not wholly
believing I am alone
Somehow I cannot go.

Elspeth Barker was also an accomplished writer, her first and only novel, *O Caledonia*, published in 1991, achieving international success and winning four literary awards. The couple's daughter, Raffaella, described her chaotic upbringing in *Come and Tell Me Some Lies* (1994).

Bintry House, Blickling Estate, Norfolk.

Northwold, close to the Breckland area of Norfolk, is associated with **John Cowper Powys** (1872–1963). He was born in Derbyshire, and educated at Corpus Christi college, Cambridge. He became acquainted with Norfolk, spending summer holidays with his grandparents at Northwold, and grew to love the local countryside. He became a prolific author, publishing fifty books. In his most acclaimed work, *A Glastonbury Romance* (1933), although chiefly a tale of King Arthur and the Holy Grail based in Somerset, the opening chapters relate to his memories of the Wissey river valley where Northwold is situated, and nearby Brandon Heath.

Shropham, a little hamlet between the Breckland area and the town of Attleborough, is associated with the writer of rural life novels **Mary Mann** (1848–1929). She was born in Norwich, the daughter of a merchant, and married Fairman J. Mann in 1871, a farmer. They moved to the family home, Shropham Manor. Norfolk, like other rural areas, was suffering from an acute financial depression, causing much hardship and suffering among the farm labouring classes.

Mary became active in the village, teaching at the local school and doing what she could to ease the plight of the poor. Her husband was also suffering from a decline in income, so Mary commenced writing to supplement the household funds. Her intense pity for the deprived local families inspired her to start writing novels dealing with the horrifying circumstances of their lives. In particular she focused on the wives and children, who in addition to semi-starvation, intense cold in winter, and appalling housing conditions, causing chronic illness and premature deaths, also suffered at the hands of brutal and neglectful men-folk.

She titled a collection of village short stories *The Fields of Dulditch*, published in 1902, and some of these short stories have been republished in *Tales of Victorian Norfolk*, edited by E. A. Goodwyn and J. Baxter in 1991. One of the most chilling is 'Little Brother', in which the narrator, like Mary Mann herself, tries to provide charity where it is needed most. She goes to visit a woman, Mrs Hodd, to offer sympathy for her thirteenth infant which has died in childbirth. She speaks to her in her bedroom where she is recovering from the labour pains, and when she goes through to the kitchen, she finds some of the tiny ragged children playing with a doll in the filthy hearth: 'They are trying to dress it with a nightgown, the elder girl is rocking it maternally and murmuring, "Theer! Put ickle arms in, Put in ickle arms...". Failing to dress it, she turned the battered-looking doll on its back, and I realised with shock, that it was the dead baby.

When I had rescued the desecrated shrivelled body and carried it to its poor bier in the mother's room, I spoke a few words to Mrs Hodd, which she resented. "Time is long for sech little uns, when t'others are at school and I'm laid by," she said. "Other folks' chil'den hev a toy, now and then, to kape 'em out o' mischief. My little uns han't. He'v kep' em quiet for hours, the poor babby have; and I'll lay a crown they han't done no harm to their little brother."'

Mary Mann published thirty-five novels and four volumes of short stories between 1883 and the end of the First World War. Despite some critical acclaim during her lifetime, she is largely forgotten now. She is buried in the churchyard at Shropham beside her husband. I hope this brief account of her career may encourage more admirers of her unique and unflinching insight into the lives of the rural poor in the late Victorian period.

Mary Mann and her family.

Suffolk

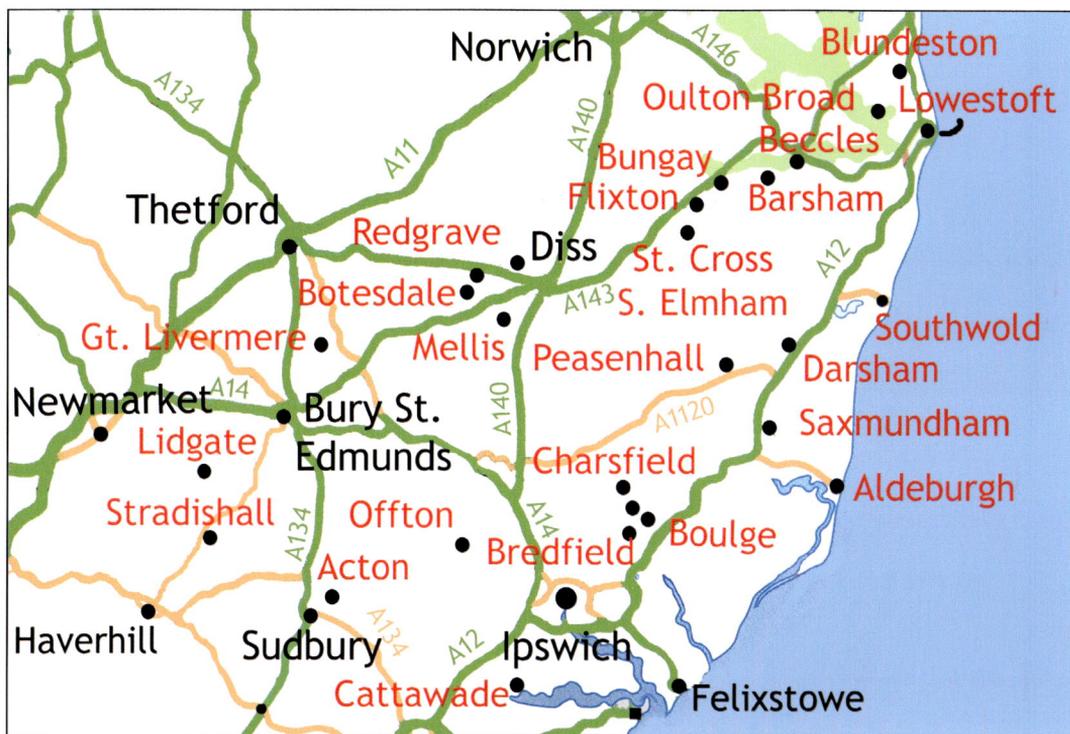

Map of Suffolk by Karen Leah.

Bungay, on the Norfolk/Suffolk border, is the most attractive and fascinating of all the Waveney Valley towns. Close to the river and in a small circumference, it comprises a variety of ancient buildings and sites: a well of spring water in use since the Roman period; the Saxon Trinity church; the Norman Castle built for the Bigod family in 1165 and one of the most powerfully defensive fortresses in the kingdom; ruins of the thirteenth-century Benedictine Priory, attached to St Mary's Church with its lofty tower; and the distinctive eighteenth-century Butter Cross surmounted by the elegant lead figure of Justice.

Elizabeth Bonhote (1744–1818) was born in Bungay, the daughter of James Mapes, a prosperous baker and confectioner. Her unfortunate mother gave birth to a number of sons, all dying in infancy; Eliza was the first child to survive and grow up strong and healthy. For this reason, she was treasured by her father, and because she proved to be

Bungay Castle, eighteenth century.

clever and eager to learn, he provided education for her with the local vicar, so she enjoyed a more extensive education than most young women of the period.

A prolific reader, she decided to become a writer herself, publishing verses in the local periodicals. Growing more ambitious, she produced a novel, *Hortensia*, in 1769, influenced by Samuel Richardson and his enormously popular *Clarissa*, and thus became one of a growing number of women authors, writing mainly for a female readership and focusing on domestic themes and problem marriages. They gained disapproval, as it was felt that a woman's role should remain within the domestic sphere caring for husbands and children, with no other occupations beyond embroidery, drawing and playing the piano.

She married Daniel Bonhote in 1772, a prosperous Bungay attorney. He had no objection to her authorship, and she went on to publish several more novels. The ancient remains of Bungay Castle had come into the ownership of a local developer who started to strip it for building materials. Horrified by this vandalism, Eliza urged Daniel to purchase the property, and she then wrote a romantic Gothic tale and ghost story, *Bungay Castle*, in 1796, imagining its inhabitants in the medieval period. It proved a popular success, and the outcome was that antiquarians became more interested in the building, its history and preservation. In the following century, improvements were made, and it is now designated an Ancient Monument in the care of Historic England.

So well done Eliza, not only a pioneer female novelist, but also a pioneer conservationist!

Above left: Frontispiece of *The Parental Monitor*, by Elizabeth Bonhote, published by William Lane, 1788.

Above right: Interior of the Fisher Theatre, Bungay, where Charles Dickens attended a lecture by Daniel O'Connell in 1836.

Charles Dickens visited Bungay in 1836, when he was still just a newspaper journalist with the *Morning Chronicle*. He travelled from London to report a public dinner in the Corn Hall to promote the Whig Reform movement, with guest speaker the Irish political leader Daniel O'Connell.

Bungay's other distinguished and more recent novelist is **Elizabeth Jane Howard** (1923–2014). She was born in Bedford Gardens, Kensington, London, to a wealthy family, and was educated at home, having a governess and visiting teachers. She married Peter Scott, the naturalist and artist specialising in painting wild birds, and they had a daughter, Nicola, but were soon separated and divorced in 1951. She became a writer and gained instant success with her first novel, *The Beautiful Visit*, which won the John Llewellyn Memorial Prize in 1950. Other successful novels followed. In 1965 she married the best-selling author Kingsley Amis, and they lived in Barnet. He had two sons by a previous marriage, one of whom, Martin, born in 1949, also became an acclaimed writer. The marriage broke up in 1983.

In the 1990s she commenced the family chronicles featuring generations of the Cazalet family from the late nineteenth century into the world war periods. The five volumes became best-sellers, the final instalment *All Change*, being published in 2013.

Elizabeth Jane Howard. (© Daily Mail/REX/Shutterstock)

In 1990 she had moved to Bungay, having fallen in love with a large seventeenth-century house by the river in Bridge Street when she was visiting friends nearby. In Bungay, she continued to write the Cazalet novels, and also *Slipstream*, a memoir of her life and career (2002).

She created a beautiful garden area, which included a narrow strip of island close to the Falcon Meadow by the river, and where in the spring hundreds of daffodils are reflected in the tranquil waters. She became a keen supporter of the newly renovated Regency Fisher Theatre and also the town library, assisting with fundraising when its future was threatened if Suffolk County Council withdrew financial support.

She died in 2014, and there is a plaque by the Bridge Street house door commemorating her residence there. A biography, *Elizabeth Jane Howard: A Dangerous Innocence*, by Artemis Cooper was published in 2016.

Beccles is 7 miles from Bungay and is also a small market town in the Waveney Valley. The two towns had approximately the same population in the Victorian period, but Beccles has flourished considerably recently, partly because it has retained its River Waveney links with the Norfolk Broads, which bring in thousands of holidaymakers in the summer months, whereas the river in Bungay gradually silted up in the twentieth century and is now only navigable for small boats and canoes. Also, whereas Bungay's

The River Waveney at Beccles.

railway passengers station closed in 1953, and the goods station in 1963, the Beccles line has stayed open, retaining links with Lowestoft and Ipswich with connections to London.

Sir John Suckling (1609–42), poet and dramatist, was born in Middlesex and educated at Trinity College, Cambridge, the son and heir of Sir John Suckling. He inherited his father's title and the manor house estate Barsham Hall, near Beccles, and close to Barsham church, now demolished, and also the nearby handsome red-brick Roos Hall, built in 1588.

Following his father's career, he was courtier to King Charles I, and both men had their portraits splendidly painted by the Court painter, Van Dyck. When the king issued a proclamation that the gentry should spend more time on their own estates he settled for periods at Roos Hall, where he wrote various dramas and poems, of which the best known is 'Why so pale and wan, fond lover', which frequently appears in poetry anthologies.

He also spent time at Barsham and raised a troop of yeomen to assist the king in his conflict with the Scots (1638–39). They must have created an amazing spectacle for local labourers and village people to gawp at because the gossipy biographer John Aubrey describes them thus:

Sir John Suckling Jr engraving.
(© Yale University Press)

a troop of a hundred very handsome young proper men, whom he clad in white doublets, and scarlet breeches, and scarlet coats, hats and feathers, well hosed and armed. They say 'Twas one of the finest sights in those days … The ladies opened the windows to see so fine and goodly a sight-O.'

Aubrey also mentions 'I have heard Mrs. Bond say, that Sir John's father was but a dull fellow … the wit came by the mother.'

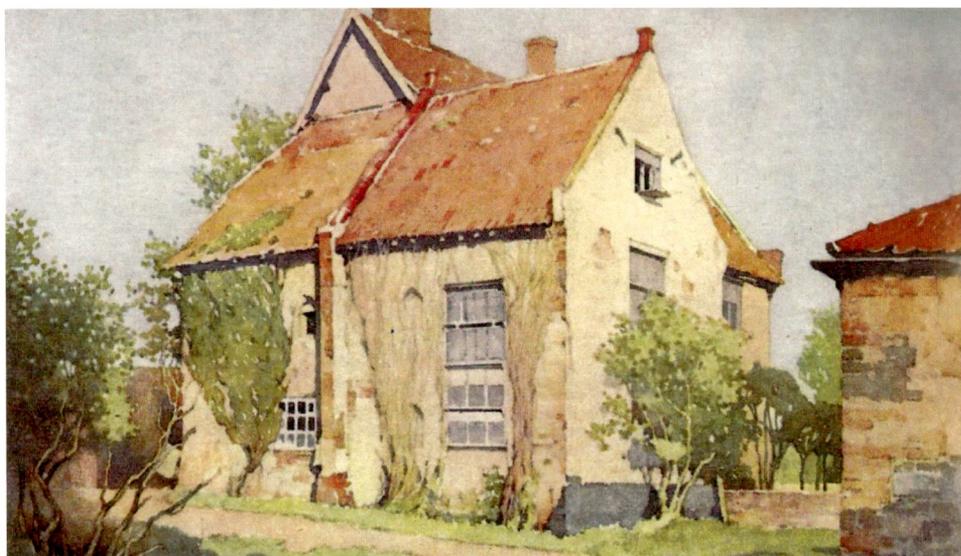

Old Hall, Barsham, Suffolk – watercolour by Walter Dexter, *Some Literary Associations of East Anglia*, W. A. Dutt, 1907.

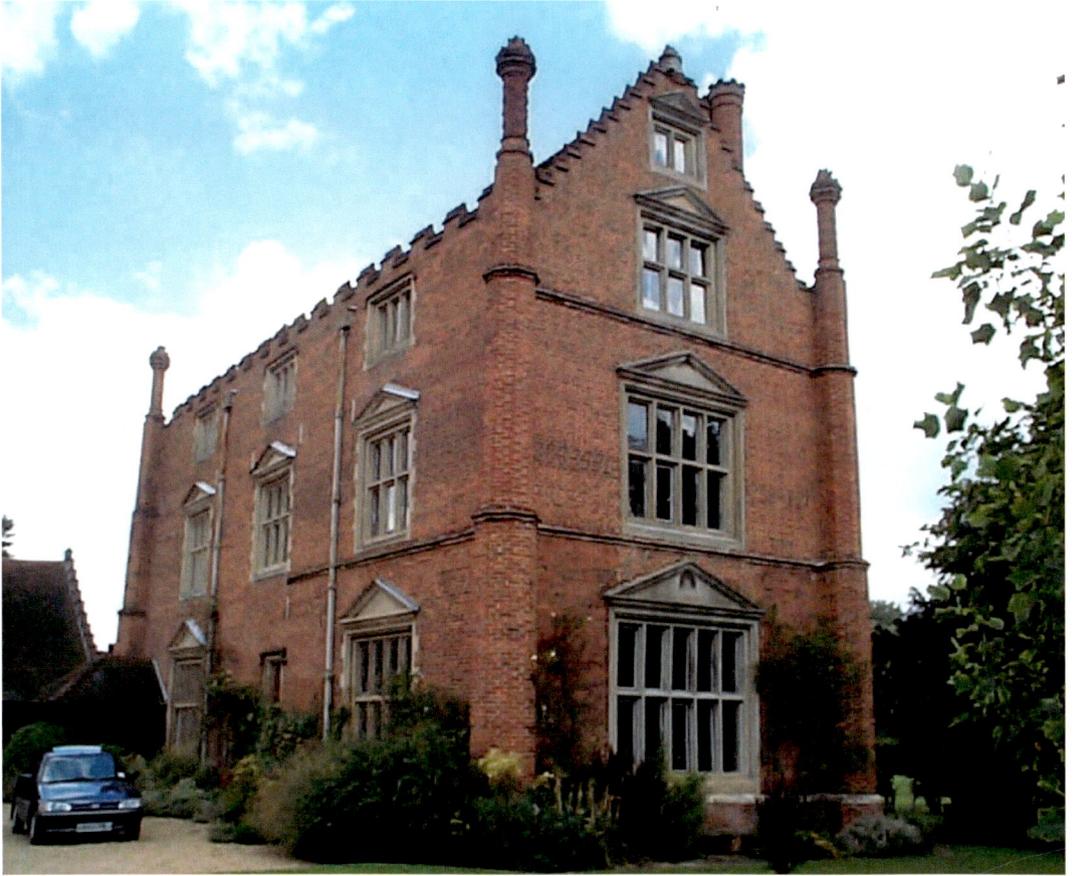

Above: Roos Hall, Beccles, another residence of the Suckling family.

Right: Suckling family tomb and memorial in St Andrew's Church, Norwich.

His involvement in Royalist political intrigue caused him to flee to Paris in 1641, where he fell into poverty and, it is thought, committed suicide.

There is a splendid monument to Sir John Suckling senior and his wife in St Andrew's Church, Norwich. The wife is lying flat on her back on the flat table top of the tomb, and Sir John is leaning forward, his chin resting on his hand, gazing at his wife affectionately. Three of their children appear on the carved frontal of the tomb.

Adrian Bell (1901–80) became a farmer and novelist of farm life. He was brought up in London and educated at Uppingham School, Rutland, where he was 'beaten, bullied, robbed, swindled and taunted'. He developed into a sensitive book-loving youth who decided as a teenager that his ambitions were to write poetry and manage a small farm, both of which he successfully achieved. He was first apprenticed at Farley Hall farm, near Darsham, in October 1920, and immediately delighted in the open-air labour in the tranquil West Suffolk countryside. A year later his father bought him his own small farm estate at nearby Stradishall, and, at a youthful age, he became *My Own Master*, the title he gave to his account of his early life in 1961.

Between 1930 and 1932, he published a trilogy, *Corduroy*, *Silver Ley*, and *The Cherry Tree*, which promptly established his popularity and fame.

He continued to combine his love of farming and country life with writing, and published twenty-four books including a slim volume of poetry in 1935, and also wrote regular articles on rural themes for the *Eastern Daily Press*.

Following his retirement from farming in 1954, he and his wife moved to live in Beccles, at 19 Northgate, with a view over the River Waveney, where they remained until his death in 1964. There is a commemorative plaque on the house front. He is buried in the churchyard in nearby Barsham.

Adrian Bell. (© Eastern Daily Press Newspapers)

Birthplace of George Crabbe at Aldeburgh – eighteenth-century engraving.

Other writers associated with Beccles include the poet **George Crabbe** (1754–1832), born in Aldeburgh on the Suffolk coast, the town with which he is most associated. He had schooling in Bungay, and later courted a Beccles girl, Sarah Elmy, whose parents lived on the north side of Market Street. They were married in Beccles church in 1783. Sarah was a huge support for George, and he missed her terribly when she died in 1813.

Crabbe described Beccles as 'that delightful town – the gem of the Waveney'.

Lowestoft is a seaside town nearing the end of the Waveney Valley as the river becomes tidal approaching Breydon Water and flows into the sea near Gorleston, Norfolk. **Thomas Nashe** (1567–1601) was born in the town. His father was a church minister, and Nashe was educated at St John's College, Cambridge. There he and the dramatist Robert Greene (*see* Norfolk section), both undergraduates, became friends,

Nashe was known as one of the 'University Wits', a pamphleteer and story writer. Although he was involved with new developments in drama, and contributed to Christopher Marlowe's *Dido Queen of Carthage*, preparing it for stage performance in 1596, he wrote no play that has any continued success today.

His play *Pierce Penniless, the Isle of Dogs* (1597) was an attack on abuses in government, and the result was that it was condemned for performance, the theatre where it was performed in London closed down, and Nashe was committed to the Fleet prison.

Thomas Nashe – sketch portrait.

His last work, *Lenten Stuffe* (1599), was a pamphlet in praise of the red herring trade which made Lowestoft and Yarmouth prosperous, and a satire on the towns, fish being the chief permitted food during the fasting period of Lent.

He and Greene continued to be wild and dissolute characters, and during an orgy in Yarmouth, where they overindulged in a meal of pickled herrings, washed down with large quantities of ale, Greene overdid it and died, in 1601. His death left Nashe the chief exponent of realism and an important figure in the development of English prose, writing in natural and vivid conversational style.

George Orwell – sketch portrait, illustrated in *Writers of the Waveney Valley*, Ruth Walton, 2019.

George Orwell, the pen-name of Eric Arthur Blair (1903–50), essayist and novelist, has associations with the delightful seaside resort of Southwold, so popular that it is thronged with visitors throughout the year, not just in the summer months. He was born in Bengal and educated at Eton. His family moved to Southwold in 1921, and Eric went off to Burma, where he spent five years with the Indian Imperial Police service. He returned from time to time to visit his parents who lived in Montague House, 36 High Street, and a commemorative plaque records the writer's residence. He made it plain that he disliked what he considered the introverted rather snobbish and gossipy character of the town, and he found little social life to enjoy; nor did he appreciate the local surroundings and landscape. He uses it as the location for his novel *The Clergyman's Daughter* (1935), belittling it in various ways:

> if you chose to climb the church tower, you could see ten miles or so across the surrounding country. Not that there was anything worth looking at, only the low barely undulating East Anglian landscape, intolerably dull in summer but redeemed in winter by the recurring pattern of elms, naked and fan shaped against leaden skies

But the novel is a jolly good read, different in character from the author's more famous works *Down and Out in Paris and London* (1933), drafted in his bedroom in his parents' home, and later on, *Animal Farm* (1945) and *Nineteen Eighty-Four* (1949).

Southwold beach.

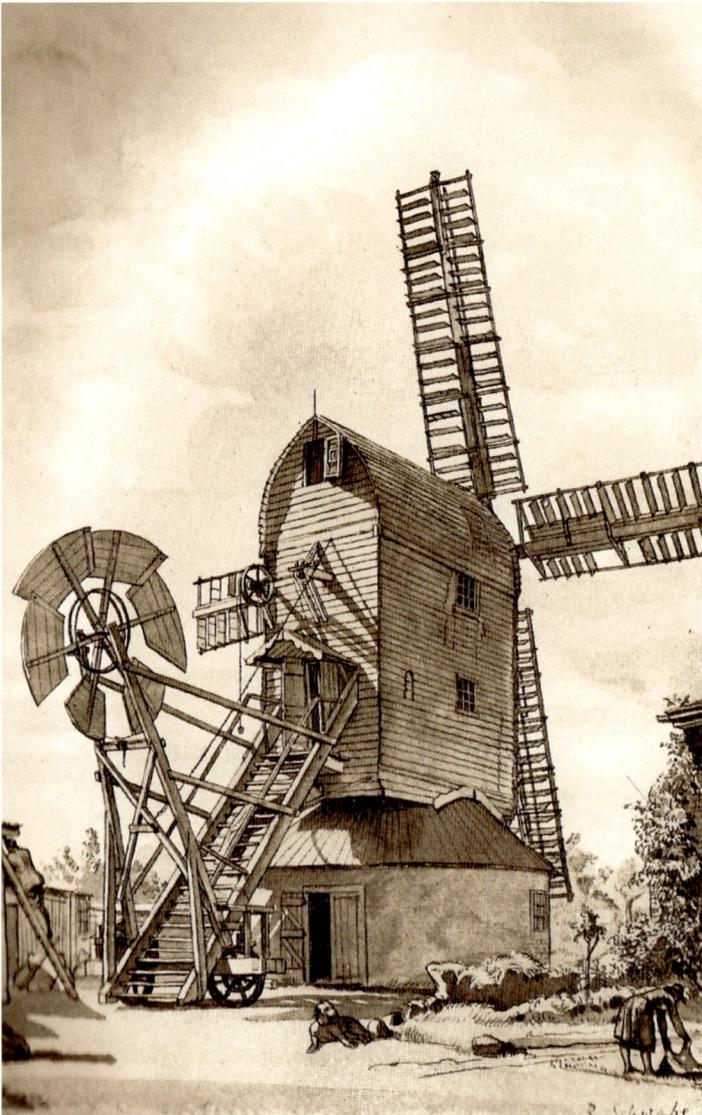

Windmill at Peasenhall – illustration by R. Schwabe in *Suffolk Scene* by Julian Tennyson.

The inland village of Peasenhall, near Framlingham, is not far from Southwold and was the parental home of **Julian Tennyson** (1915–45). His family had Suffolk origins dating back six centuries, and they lived in the Ancient House in Peasenhall. Julian was the great-grandson of the poet Alfred Lord Tennyson.

His book *Suffolk Scene*, published 1939, describes his walking tours around Suffolk. It was celebrated when published and has become a classic of Suffolk literature, recently reprinted in a new edition. He describes the unassuming and serene character of the county, so uplifting to the mind and spirits:

> Suffolk takes great care to conceal its charms ... chiefly by means of the hedges. The
> hedges are the key to the variety of the fields, and to the wildness and uncouthness

of the whole county. They are fascinating, extravagant, and dramatic ... overblown and unruly, and of all the jumble that clings about them I like the dog-roses best. Oh, those June roses in Suffolk, with their wide, delicate cups of pink and white ! Nowhere else have I seen them in such mass and riot, for nowhere else do they have the chance to grow as they please, year after year. For one month they run wild over the hedgerows, and their soft spreading brightness blinds you to the deeper colours beside them. Their scent is sweet and slight, so that the faintest wind carries it beyond your grasp; but in the evenings, when the breeze has died away, it hangs about the lanes so heavily that it overrides even the scent of the hay in the neighbouring fields.

The book was published just in the year of the outbreak of the Second World War. Julian was killed in action in Burma.

Dust-wrapper of *Suffolk Scene*, 1939, by Julian Tennyson, Blackie & Son Ltd.

Ronald Blythe (1922–2023) was born into a farming family in Acton, near Sudbury, and was educated at the local school. He became a voracious reader and grew up with a love of exploring the local churches, other old buildings, nature and plants.

When he left school he worked in Colchester Library and started publishing poems, essays and short stories. In the 1950s he moved to Debach, a little village not far from Ipswich, and published his first book, a novel set in the Suffolk countryside, *A Treasonable Growth* (1960).

Becoming involved with the local community inspired him to write a study of the rural inhabitants, many of whom were agricultural labourers. He commenced compiling information in 1967, and the local village of Charsfield was given the fictitious name of Akenfield, published in 1969. His interviews with three generations of local people resulted in an account of agricultural life in Suffolk from *c.* 1880 to the 1960s. He wrote:

> In the church at Akenfield there is a long list of names and few remember who they were, or what they looked like. Yet they were alive in our own century. So one wonders about the generations before. This is how the book began. A sort of compassion for farming people.

In fact, his characters are from a wider social class, and include school teachers, a retired colonel, and a major, a lady magistrate, and other ladies who performed good works in the village and region. But the main thrust concerns the poorer classes and the various ways in which they suffered extreme deprivation during periods of decline in the rural economy.

One of the most shocking revelations is the extreme class divide between the gentry and the labouring classes, as described by Christopher Falconer, who was employed to work as a garden assistant along with seven other gardening staff, when he was fourteen, for Lord Covehithe who had a large estate at Easton.
He recalls that the

> Lord and Ladyship were very, very Victorian and very domineering ... it was a frightening experience for a boy. It was 'swing your arms', every time they saw us. Ladyship would appear suddenly from nowhere when one of us boys were walking off to fetch something, and 'Swing your arms!' she would shout. We wore green baize aprons and collars and ties no matter how hot it was ... We must never be seen from the house, it was forbidden. And if people were sitting on the terrace or on the lawn, and you had a great barrow-load of weeds, you might have to push it as much as a mile to keep out of view. If you were seen you were always told about it, and warned, and as you walked away Ladyship would shout after you 'Swing your arms!'. It was terrible. You felt like somebody with a disease.
>
> It was the same in the house. If a maid was in a passage and Lord or Ladyship happened to come along, she would have to face the wall and stand perfectly still until they had passed. I wouldn't think that they felt anything about their servants. We were just there because we were necessary, like water from a tap. If we heard them in a certain walk, we had to make a detour, if not, it was 'But why weren't you listening?' and 'Be alert, boy!', and when you had been dismissed 'Swing your arms!'.

Dust-wrapper, *Akenfield*, by Ronald Blythe; painting of Blythburgh by Edward Seago, 1969. (Alan Lane, The Penguin Press)

Soon after publication it rapidly became a best-seller, not just in Britain but also in the States, appealing to those who had ancestors living in the Suffolk region. The book was also made into a film by celebrated director Peter Hall in 1974, using a cast of Suffolk villagers, and this added to its fame and popularity.

Blythe was the author of a total of thirty-six books and in 2006 was awarded a Benson Medal for lifelong achievement by the Royal Society of Literature, and appointed a CBE in the 2017 Birthday Honours for services to literature. His most recent book is *Next to Nature – A Lifetime in the English Countryside* (2022). He reached his 100th year in the November and died in January the following year.

Aldeburgh, the major seaside resort between Southwold and Felixstowe, is most associated with the poet **George Crabbe**. He was born there in 1754, and following schooling in Bungay and Stowmarket, trained as a surgeon in London and returned to establish his medical practice back in his home town. In Crabbe's lifetime Aldeburgh wasn't the attractive and popular holiday resort it has become, associated with cultural

arts and literary events, but was run down and poverty-stricken due to the decline of the previous successful shipbuilding industries. Crabbe wrote of the poor fishing community:

A wild amphibious race,
With sullen woe displayed in every face.

He was becoming increasingly focused on writing poetry, and his first published poem was 'Inebriety' (1775). Realising he was unlikely to attract attention in the rural area he moved to London in 1780, but lack of success resulted in poverty.

His career took a turn for the better following the publication of *The Library* in 1781, attracting the attention of Edward Burke, the Whig statesman and philosopher, and getting introduced into wealthy social circles. He then decided that a career in the Church would enable him to obtain a regular income as well as providing leisure time to pursue his literary ambitions, and he obtained a parish at Belvoir in Rutland.

The Village (1783) was sponsored by Burke and was an exposure of the harsh realities of the rural labourers' lives. It was praised by Dr Johnson and greatly enhanced his popularity. His popularity further increased with the narrative poems 'The Parish Register' (1807) and *The Borough* (1810). The latter features the poem which inspired the Suffolk composer Benjamin Britten to write one of his most popular operas, *Peter Grimes*.

Ipswich is the capital of Suffolk. It is quite small and has no cathedral, so it remains a town, not a city. **William Cobbett** toured East Anglia in 1830 and recorded his impressions in his *Rural Rides*. He was impressed with Ipswich, and wrote: 'From Eye to Ipswich we pass through a series of villages, and at Ipswich, to my great surprise, we found a most beautiful town, with a population of about twelve thousand persons ... and most abundant evidence of prosperity for the new houses are indeed very numerous.' He continued, 'The town itself is substantially built, well-paved, everything good and solid, and no wretched dwellings to be seen on its outskirts.'

He also admired what an inspiration the rural landscapes, with their varying scenery and immense skies, were for artists. The poet Edward Thomas wrote of Cobbett, 'His pen was as good as a sword, a short, thick, sword, with a point as well as an edge.'

Edward FitzGerald (1809–83), poet and translator, was born in Bredfield near Woodbridge, and not far from Ipswich, of wealthy parents. They later moved to nearby Boulge Hall, a grand Queen Anne mansion, but 'Fitz' disliked both the house and the surrounding countryside: 'One of the ugliest places in England – one of the dullest – it has not the merit of being bleak on a grand scale – pollard trees over a flat clay soil, with regular hedges.'

He was educated at Trinity College, Cambridge, and after graduating spent most of his life in the Suffolk region of his birthplace, for many years in lodgings in Woodbridge on Market Hill. A plaque commemorates his residence there.

He was very fond of sailing and boating on the nearby Deben Estuary and befriended the local fisher-folk; he formed a close personal attachment with Joseph 'Posh' Fletcher. The two friends went into business together, buying a fishing trawler as Fitz loved nothing better than messing about in boats. Sadly, the partnership terminated because

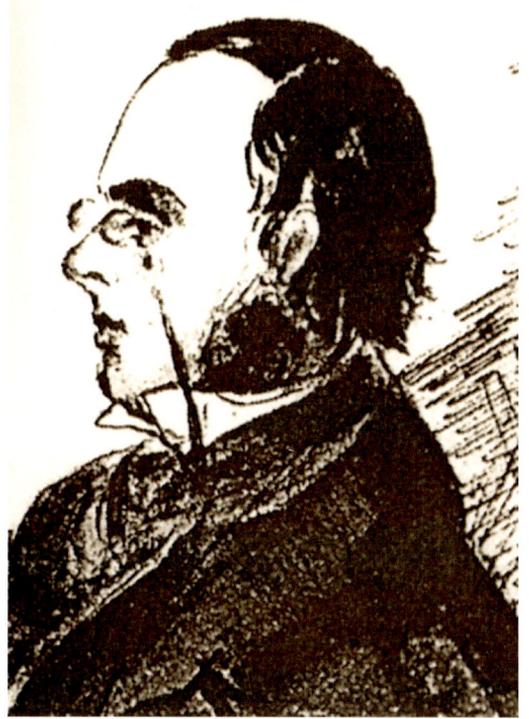

Right: Portrait sketch of Edward FitzGerald (artist unknown).

Below: House in Market Hill, Woodbridge, occupied by Edward FitzGerald from 1860.

'Posh' was asked to abstain from strong alcohol, which was causing erratic behaviour, but he couldn't resist it. Fitz lost confidence in him, although otherwise his affection and respect remained unabated.

Fitz published various poems and translations including six plays by the seventeenth-century Spanish dramatist Pedro Calderon de la Barca, and works by Aeschylus and Sophocles, but the work that brought him enduring fame is the *Rubaiyat of Omar Khayyam*, a free translation from the Persian, the first edition published in 1859. It has achieved international popularity and has been published in various attractive illustrated editions in Britain.

Fitzgerald's translation reduces the poem from 235 to seventy-five four-line verses, featuring the reflective wisdom of the Persian eleventh-century astronomer-poet mingled with Fitz's melancholy broodings, creating a uniquely fascinating work of art. It has been described as more of a fantasia of the original than a translation.

His version concludes:

Ah, Love! Could thou and I with Fate conspire
To grasp this sorry Scheme of Things entire,
Would not we shatter it to bits, and then
Re-mould it nearer to the Heart's Desire!

Dust-wrapper, *The Rubaiyat of Omar Khayyam*, Edward FitzGerald, designed by Otway McCannell, *c.* 1930.

Fitz was buried in the Boulge churchyard of St Michael and All Angels – not in the grand family mausoleum, but beneath a simple granite tomb and cross nearby. A rose tree from the tomb of Omar Khayyam at Nishapur was planted by members of the Omar Khayaam Club in 1993, and I believe it continues to flourish today.

H. W. Freeman (1899–1994) was brought up at Bruisyard near Framlingham where his father had a poultry farm. He gained a degree in Classics at Oxford and then decided to devote himself to his abiding passion for travel and the desire to become an author.

> I would do a temporary teaching job and would go abroad on my savings for as long as they would last, to write a manuscript for rejection. That was how, after four years and three rejections I came to write *Joseph and His Bretheren* (1928), in an upper-room off a sleazy street in Florence... in the process of arriving at publication I had come to acquire a taste for the vagabonding, half-picaresque life I had chosen to lead.

Joseph won immediate acclaim, and went rapidly into six editions. The Norwich author R. H. Mottram wrote a preface affirming, 'It does for the life of East Suffolk what Hardy does for Wessex.' Despite Freeman's extensive travels, walking and cycling with a pack on his back in Italy, France, Spain, Scandinavia, Rumania, Sardinia and Calabria, his native Suffolk and the farmland where he grew up was an abiding theme and his best work is considered to be local in character. *Hester and Her Family* (1936) is his most ambitious novel, and the first half is set in Suffolk and the remainder mainly in Italy, but there is no farming interest, observed as a deficiency because he writes so well on farming themes. His other most popular novel is *Chaffinch's* (1941), and the success of this and *Joseph* financed his travels abroad. He spent most of his writing life in Offton, a little village not far from Ipswich in a house called The Mutton.

Cattawade is a village close to Manningtree and the River Stour. The Cattawade bridge is an ancient structure crossing the Stour leading from the ancient kingdom of East Anglia into Essex.

Thomas Tusser, poet, was educated at Cambridge, and then farmed at Brantham Hall, near Cattawade, gaining prestige with his introduction of barley crops, and where he wrote his classic work *Hundreth Good Pointes of Husbandrie* (1557).

It proved very popular and was published in five editions during his lifetime. Written in verse, it provides practical advice on farming, housekeeping, gardening and general moral conduct, with maxims which still relate to proverbs in modern speech today and has been praised for its 'ripe and shrewd wisdom, and astonishing metrical and verbal ingenuity'.

Despite the book's success, Tusser fell on hard times, living in Norwich for a period, and later died in a debtors' prison in London.

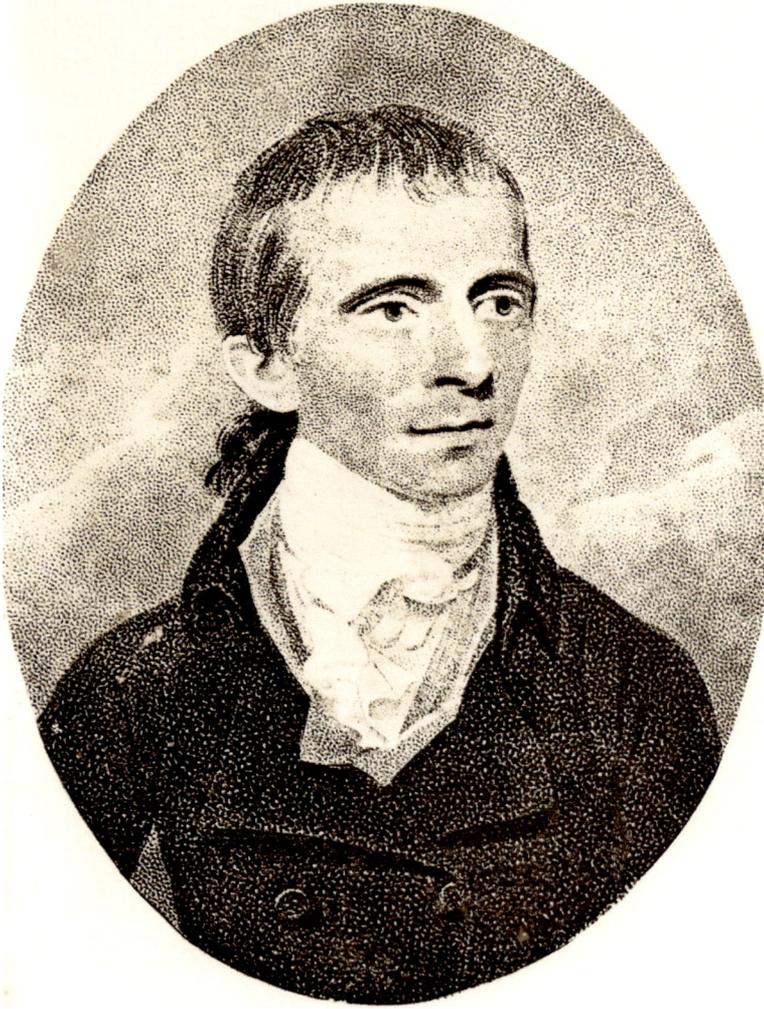

Stipple engraving
portrait of Robert
Bloomfield, *c.* 1796

Robert Bloomfield, pastoral poet (1766–1823), was born in Honington not far from Bury St Edmunds. Of humble parentage, his father was the village tailor, but he died of smallpox when Robert was only a year old. His mother kept the local dame's school to earn a living, and provided Robert with a good education. They occupied a cottage close to the village church, and the property still exists, now divided into Bloomfield Cottage and Bloomfield Farmhouse. Robert commenced work as a farm labourer and then gained employment with his brothers, working as shoemakers in London. While living there, he was described as 'a slender, dark little man, hardly more than five feet tall, of melancholy appearance, whose goodness of disposition and mildness of temper were the subject of much comment'.

He developed a love of poetry and determined to be a poet himself. His long poem 'The Farmer's Boy' (1800) was published with instant acclaim. It provides insight into Suffolk rural life in the late Georgian period when changes were occurring in farming

and agriculture. Four editions followed by 1801, and the title page states, 'A Shepherd's boy, he seeks no better name'. His love of nature is epitomised in this extract, describing Giles, the farmer's boy, lying in a sunny field:

Just where the parting bough's light shadows play
Scarce in the shade, nor in the scorching day,
Stretched on the turf he lies, a peopled bed
Where swarming insects creep around his head.
The small dust-coloured beetle climbs with pain
Oe'r the smooth plantain leaf – a spacious plain !
Thence higher still, by countless steps conveyed
He gains the summit of the shivering blade.
And flirts his filmy wings, and looks around,
Exulting in his distance from the ground.
The tender speckled moth here dancing seen,
The vaulting grasshopper of glossy green,
And all prolific Summer's sporting train
Their little lives by various powers sustain.'

There is a brass shield commemorating him in Honington church.

Engraving from Bloomfield's *The Farmer's Boy*, 1800.

Apart from Ipswich, Bury St Edmunds is the major town in West Suffolk, and is particularly highly rated for the ruined remains of the Abbey and the beautiful public gardens attached to it which are full of colourful blooms throughout the year. The Norman Tower, which formed the grand entrance to the Abbey precincts, is considered one the finest medieval monuments in the kingdom and in a fine state of preservation.

Jocelyn of Brakelond (1155–1202) was a chronicler of monastic life at the Abbey. He was born in Bury and entered as a monk at the Abbey in 1173 when he was twenty-two. He wrote a brief but fascinating account covering the years 1173–1203, and in particular a lively portrayal of Abbot Samson who was acclaimed for initiating various reforms during his period of office. Samson obviously liked and respected Jocelyn, for he chose him as his personal chaplain, and this role gave the monk illuminating insight into the abbot's charismatic personality and behaviour.

The Norman Tower – entrance gateway to the Abbey of Bury St Edmunds.

Jocelyn was virtually unknown as a writer until the Victorian historian Thomas Carlyle featured him and his *Chronicle*, in his book *Past and Present*, published in 1843. The book proved to be popular with a general readership, and Carlyle painted a vivid picture of the monk, summarising his character as 'ingenious and ingenuous, a cheery-hearted, innocent, yet withal shrewd, noticing, quick-witted man; and from under his monk's cowl has looked out on the (monastic) world, in a really human manner'.

John Lydgate, poet (1370–1450), is named after the village of Lidgate where he was born and where his family originated, a few miles distant from Bury. His ancestral home still survives, a fourteenth-century timber-framed building named Suffolk House on the village main street, recently rebuilt.

Like Jocelin of Brakelond, he was a monk in the Bury Abbey, taking his vows at the age of fifteen, and ordained in 1397. He performed a role as a tutor in literature and wrote a considerable quantity of poetry, his most highly rated poem being 'The Life of Our Lady'. The Abbey provided the advantage of having one of the finest libraries in the kingdom.

He also wrote a life of Saint Edmund in verse, which describes the legends connected with him, and a history of the Abbey, a description of the saint's famous and miracle-working shrine, and brief histories of the various abbots. The manuscript copy is in the British Library and it is one of the most beautiful documents ever produced, written on vellum and illuminated with 120 images in rich and exquisite colours.

He was Court Poet during the reign of Henry V, but after a period of several years returned to the Abbey, where he died. There is a brass memorial commemorating him in the chancel floor of the cathedral .

William Cobbett visited Bury St Edmunds in 1830, during his extensive 'Rural Rides', and described it as 'a very pretty place; extremely neat and clean; no ragged or dirty people to be seen', and agreed with the residents that it was 'the neatest place that ever was seen'.

Montagu Rhodes James (M. R. James, 1862–1936) was born at Goodnestone, Kent, but was brought up at the Vicarage, Great Livermere Hall, near Bury St Edmunds. The hall was later demolished, but the gardens and park remain, and it has been commented that the mere in the grounds, Ampton Water, 'As the light fades ... conveys something of the spooky atmosphere'. This perhaps inspired some of James's tales.

He was educated at Eton and Cambridge, and had a distinguished career involving archaeology, medieval studies and palaeography. He subsequently became Provost of King's College, Cambridge, Provost of Eton school, and was a Director of the Fitzwilliam Museum in Cambridge. He became well known for his various scholarly works, one of which was *Norfolk and Suffolk* (1930), illustrated with a variety of photogravures and numerous line drawings by G. E. Chambers. James writes in the Preface: ' I have many early associations which endear these two great counties to me, and the attempt to expound some of their manifold attractions to those who live in them and those who visit them has been a very pleasant task'.

But his continuing popularity rests more on his stories of the supernatural, of which *Ghost Stories of an Antiquary* (1904) is the most acclaimed. It was followed by three more

collections, and their appeal is based on his scholarly attention to historical detail, which provides an air of authenticity, and also the evil and horrifying events that are hinted at, leaving much to the reader's imagination. A typical example is 'Oh, Whistle and I'll Come to You, My Lad' (1904), set like many of his stories in East Anglia.

The thatched church near Livermere Hall has carved bench ends of weird animals, and James features them as coming alive, and furry when handled by the terrified parson in one of his tales in *Collected Ghost Stories* (1931).

He was awarded the Order of Merit in 1930.

Cambridgeshire

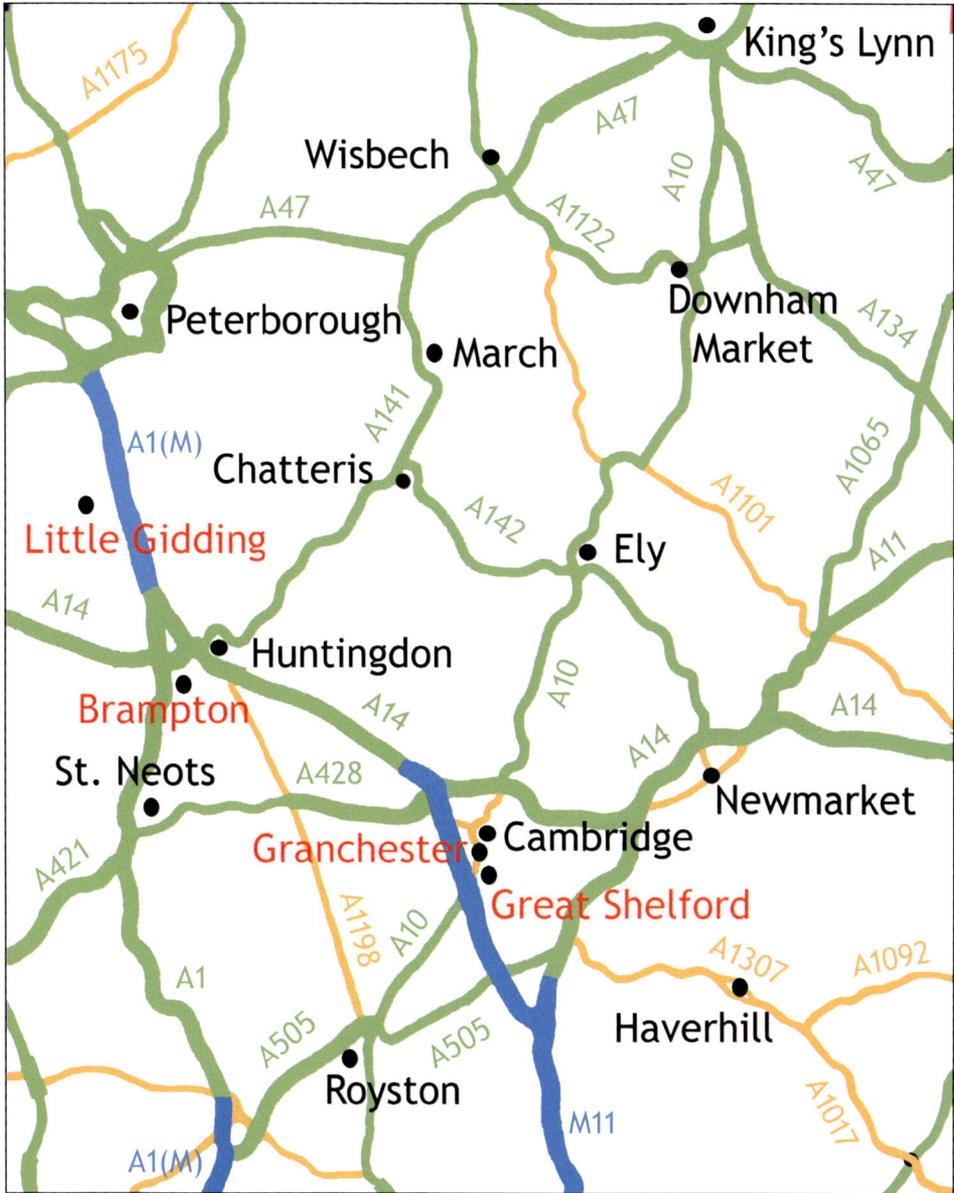

Map of Cambridge by Karen Leah.

Cambridgeshire is best known for its university, and its origins as a centre of higher education commenced in the thirteenth century. In the late twelfth century Oxford was an important centre for learning but various problems and arguments resulted in students moving out, and some began to congregate in Cambridge. It developed its own permanent institution and the first chancellor was recorded in 1225.

Peterhouse was the first college to be founded, in 1284, and gradually others were established, twenty-eight by the end of the twentieth century.

Peterborough is a cathedral city on the River Nene, not far from Stamford.

The *Anglo-Saxon Chronicle*, which was compiled in the late ninth century during the reign of Alfred the Great, exists in its most final version, taking the text to 1155, in the city's Benedictine Abbey. The Abbey church, built in the early twelfth century, became the cathedral in 1541.

L. P. Hartley, who was born at Whittlesey 5 miles east of Peterborough, spent his youth at Fletton Towers, the family home. The surrounding area was occupied by brickfield industries, and one of his lesser-known and late novels is *The Brickfield* (1964).

Huntingdon is a town around 3 miles east of the A1. A large mansion house, Hinchingbrooke, was built for the Cromwell family. It was later bought for the Montagu family and became the home of Sir Edward Montagu, Lord Sandwich, who was related to the eminent diarist Samuel Pepys. Pepys was educated for a short time at the Free School in Huntingdon High Street, the building now preserved as the Cromwell Museum. Sir Edward employed him in his household and subsequently at the Admiralty buildings in London, and it is Pepys's career and connections in London which form so much of his diary's fascinating contents, covering the years 1660–69.

He continued to visit his Montagu relatives in the Huntingdon area, and on one occasion records being choked by dust caused by building work being carried out at Hinchingbrooke. The mansion became the Free Grammar School and later a Comprehensive School. (Samuel Pepys is also included in the Cambridge University section)

The grand mansion of Hinchingbrooke, near Huntingdon, owned by Edward Montagu, a relative of Pepys's.

Samuel Pepys, *c.* 1700,
by Clostermann.
(© Yale University
Press)

Swaffham Prior is a village 8 miles north-east of Cambridge, and the poet and critic **Edwin Muir** (1887–1959) and his wife Willa moved there in 1956.

Edwin wrote in a letter to T. S. Eliot:

> The little house is very charming, and we have fallen in love with it. It is in a pleasant village and looks out onto two ruined church towers, each set on a little knoll of its own; one of them damaged by lightning sometime, and the other by time itself. The neighbours are kind and the village shop is next door. I confess that sometimes I have a slightly sinking feeling knowing that now I have nothing to do but write, and must depend upon it. But I feel I will be alright.

The poems that Muir wrote there were part of his *Collected Poems* published posthumously in 1960, a year after his death. He was buried in the churchyard. His widow, Willa, was the first translator of the novels of Franz Kafka into English. She published *Living with Ballads* in 1965 and wrote an account of the couple's life together, *Belonging*, in 1968.

Charles Kingsley (1819–75), best known for his story *The Water Babies*, adored by generations of children, lived at Barnack Rectory near Stamford during his childhood,

from 1824 to 1830, and the family subsequently moved to Devon. (Kingsley is also included in the university section.)

George Herbert (1593–1633) was born in Montgomery and educated at Trinity College, Cambridge. He was made a Fellow of Trinity College in 1616, and Public Orator in 1619–27. He was a friend of Nicholas Ferrar (1592–1637), a theologian, who lived in the Manor House in Little Gidding, a small hamlet near Norman Cross. There, Ferrar established a family religious community dedicated to worship and prayer and charitable support for the poor in the vicinity.

The family held devotional services in the church nearby, three times a day, the building resembling a small college chapel.

Herbert was influenced in becoming a poet by his mother's friend John Donne (1571–1631), who became a Dean of St Paul's in London. His poetry is devoutly religious and contemplative, and the poem known as 'Love' has become acknowledged as one of the most deeply moving religious lyrics in the language:

> Love made me welcome, but my soul drew back
> Guilty of dust and sin.
> But quick-eyed Love, observing me grow slack
> From my first entrance in,
> Drew nearer to me, sweetly questioning,
> If I lacked anything.

He was ordained a priest at Fulston in Wiltshire in 1630 but died only three years later. His close friendship with Nicholas Ferrar and his family, and their dedicated religious way of life, enhanced his Christian faith, and from his deathbed he sent the manuscripts of his collections of verses, *The Temple*, *Sacred Poems* and *Private Ejaculations* to his friend. The collections were published in the following year. He remains one of the most highly venerated of devotional poets, and his verses are featured in various popular anthologies. Both men are commemorated in the Little Gidding church.

Ferrar and his community would be largely forgotten if it were not for them being featured in one of T. S. Eliot's most highly acclaimed poems, *Four Quartets* (1943), and *Little Gidding* generally considered the finest. He sensitively captures the atmosphere of the chapel interior stating that you are here to kneel, where prayer has been valid for generations, and conveying the sense of peace and silence, conducive to meditation and worship.

Geoffrey Chaucer (*c*. 1345–1400) is considered the earliest great English poet, chiefly acclaimed for his most popular work *The Canterbury Tales*, published over a period from 1387 to 1400. He had connections with the royal household of Edward III, and was employed on various missions, both in Britain and abroad, and was granted a pension by Henry IV.

He visited Cambridge, it is thought, on a parliamentary business, which resulted in him setting *The Reeve's Tale*, at Trumpington Mill, on the River Granta. The mill stood above

the mill pond which later became known as Byron's Pool, and was destroyed in a fire in 1928.

Rupert Chawner Brooke (1887–1915), who achieved supreme celebrity as a poet of the First World War, was born in Rugby and educated at Rugby School and then King's College Cambridge where he was a gifted and successful student. He became one of the select intellectual and cultural group *The Apostles* and joined the Left Wing Socialist Fabian Society, and contributed poems and reviews to the *Cambridge Review* periodical. After acting in *Dr Faustus*, he helped form the Marlowe Society.

Rupert Brooke performing as the Attendant Spirit in Milton's *Comus*, Cambridge University drama production, 1908.

In 1909 he decided to move out of university accommodation and took rooms above the Orchard Tea Rooms in Grantchester. He wrote a thesis on Christopher Marlowe, and was elected a Fellow of Kings in 1913.

At Granchester he welcomed a wide circle of friends including some of the Bloomsbury Group – Lytton Strachey and E. M. Forster. In 1910 he moved into the Old Vicarage, which was next door to the Orchard. While living there, he wrote in a letter to a friend:

> I have a perfectly glorious time, seeing nobody I know, day after day. The room I have opens straight out onto a stone verandah, covered with creepers, and a little old garden full of old fashioned flowers and crammed with roses. I work at Shakespeare, read, write all day, and now and then wander in the woods or by the river. I bathe every morning and sometimes by moonlight, have all my meals, chiefly fruit brought to me out of doors and am as happy as the day's long.

His bathing place was known as 'Byron's Pool', because George Gordon, Lord Byron, had enjoyed swimming there while a student himself in Cambridge in 1805–07, so the pool is now celebrated for its connection with two illustrious poets.

The Old Vicarage, Grantchester – woodcut by Noel Rooke, *c.* 1920.

One of Brooke's most celebrated poems is 'The Old Vicarage, Grantchester', written while he was holidaying in Germany and feeling homesick for the place he loved so dearly.

On his return, he was surprised to be welcomed back by his landlady, with the cheery assurance that 'Yes! There IS honey still for tea.' She was quoting the last line of the poem which had been published in the King's College magazine.

Brooke became idolised as the 'handsomest young man in England', admired in particular by the novelist Henry James, Edward Marsh, private secretary to Sir Winston Churchill, and Churchill himself, who established his national status as a war hero following his death during active service in the Second World War while on the island of Skyros – not during hostilities but an infection caused by a mosquito bite. He is commemorated on the war memorial in Grantchester.

We will remember him not as a war hero, or victim, but from his Cambridge days, gliding along the River Granta in a punt on a sunny afternoon, reading aloud his latest poem to an enraptured group of admiring friends.

Cambridge Town

The town of Cambridge is quite small and dominated by the university buildings and grounds, the buildings dating from various different periods, and several of great architectural beauty.

St John's College, the bridge, Cambridge.

Trinity College, Cambridge – entrance gate house and courtyard.

One disadvantage of central Cambridge is the large number of cyclists meandering or speeding in constant flotillas along the narrow, congested streets. For the students it's the easiest and most economical method of getting about, but for the pedestrians, can be a cause of alarm, having to keep dodging away from them, so that shopping and sightseeing is not always as pleasant an occupation as it should be.

Two close friends of Brooke were Gwen Raverat and Frances Cornford.

Gwendolen Mary Darwin (nee Darwin) (1885–1957) was born in Cambridge and was the granddaughter of the celebrated naturalist Charles Darwin. Darwin College, Cambridge, was housed in Newnham Grange, purchased by Charles Darwin's son in 1884. Gwen describes her childhood there in *Period Piece* published in 1952, an entertaining account of her Darwin eccentric aunts and uncles in the decades before and after 1900. It became a popular Cambridge classic and still remains in print.

Gwen was also a gifted wood-engraver and her engravings illustrate her book. She married Jacques Raverat in Cambridge in 1908 and they lived in Conduit Head Road just off the Madingley Road.

Memorial in Madingley Church, Cambridgeshire – woodcut illustration in *Mountains and Molehills* by Frances Cornford, 1934.

Her cousin Frances Darwin (1886–1960) became a minor but very gifted poet, and married Francis Cornford, a philosopher, at Cambridge. She was a great friend of Rupert Brooke whom she famously described as

A Young Apollo, golden-haired,
Stands dreaming, on the verge of strife,
Magnificently unprepared
For the long littleness of life.

Tragically ironic, as when she penned those lines, Brooke had very little life left before him.

She mixed in the Bloomsbury circles, a second generation of the celebrities including Brooke, Gwen Raverat, Daphne and Noel Olivier, and they became known as the Neo-Pagans, delighting in physical exercise, long bike rides and camping, and in poetry. Her first collection of poems was published in 1910, and *Mountains and Molehills* (1934) was illustrated with wood engravings by Gwen Raverat. Her *Collected Poems* were published in 1954, and she regularly features in anthologies.

Her son John Cornford was tragically killed fighting in the Spanish Civil War in 1936, alongside Virginia Woolf's nephew John Bell.

Frontispiece to the *Collected Poems of Rupert Brooke* – wood engraving by Gwen Raverat, the Medici Society, 1919.

The celebrated essayist **Charles Lamb** (1775–1834) and Mary Lamb, his sister, visited Cambridge in 1815 and lodged at 11 King's Parade. They walked along the 'Backs' of the college buildings facing the river, and Mary commented that they were 'walking the whole time – out of one college and into another'. Charles wrote that he so much regretted not having had a university education, and wrote a sonnet, imagining himself strolling around among the students they saw, wearing a college gown. He visited Cambridge again in 1820 and wrote a memoir, *Oxford in the Vacation*, which combines recollections of both universities.

American writer **Henry James** (1843–1916) achieved fame for his novels frequently dealing with the impact of Europe – its countries, culture and society upon Americans, and of Americans upon Europe. The most acclaimed are *Portrait of a Lady* (1881), *The Wings of the Dove* (1902), and *The Ambassadors* (1903), considered by some literary critics as his masterpiece. Shortly before his death he was awarded the British Order of Merit.

Born in New York, he travelled widely in the USA and Europe, and from 1875 settled first in Paris and then near London, at Lamb House, Rye, Sussex. He visited Cambridge in around 1880 and wrote in *Portraits of Places* (1883) admiringly of the 'Backs': 'they

Henry James. (© Smith College Archives, Northampton, Massachusetts, USA)

show the loveliest confusion of Gothic windows, and ancient trees, of grassy banks and mossy balustrades, of sun-chequered avenues, and groves, of lawns and gardens and terraces, of single-arched bridges spanning the little stream', by which he means the narrow River Cam.

In 1907 he was invited by some young students to revisit Cambridge, and stayed at No. 8 Trumpington Street. They introduced him to Rupert Brooke, and they all enjoyed being punted along the river by Rupert. James was enraptured by Brooke's beauty and personality, and it was commented that the poet had 'charmed the ageing novelist to excess'.

When Brooke died in 1915, soon after the outbreak of the First World War, James was painfully stricken, mourning 'the stupid extinction of … so exquisite a being'.

Dame Rose Macaulay (1881–1958) was born and brought up in Cambridge, where her father was a Fellow of Trinity College. She entered Somerville College, Oxford, in *c.* 1910–15, where she studied history.

She later lived in London in Dorset Street, Marylebone. She quickly established herself as a novelist of note, winning a publisher's prize for *The Lee Shore*, and *Dangerous Ages* (1921) was awarded the Femina Vie Heureuse prize.

In Cambridge, the Macaulay family had befriended Rupert Brooke, and he enjoyed the relaxing hospitality they offered him in their home at Great Shelford, where the family had settled in 1906. The recipient of much adoring adulation, from both sexes, was difficult to cope with, and he found Rose an undemanding and delightful comrade, little realising, perhaps, that she too had fallen in love with him. They shared an enthusiasm for poetry, cycling, punting and long tramps through the countryside, and nude bathing in the river and Byron's Pool. The leading character Michael, a poet, in Rose's third novel, *The Secret River* (1909), seems to be based on Brooke.

The second chapter of *Orphan Island*, 1924, features a university don's household in Grange Road, Cambridge. The historical novel *They Were Defeated* (1932) deals with Cambridge in the year 1640, and focuses on two characters, John Cleveland (1613–58), student at Christ's College and later Fellow at St John's College, and Robert Herrick, poet, educated at St John's College. It was her favourite novel, and she commented on how much she had enjoyed writing it, 'especially the part about Cambridge, which was very real to me, and so were – and are – all the people in it'. The *Sunday Times* review enthused: 'I place Miss Rose Macaulay among the three most interesting and distinctive women novelists in England today.'

One of her last novels, *The Towers of Trebizond*, won the James Tait Black Memorial Prize.

As an acclaimed author in the 1930s, she moved in some of the same literary and social circles as Virginia Woolf. Woolf makes quite frequent references to her in her Letters and Diaries, but had little affection or respect for her, either as a person or writer. So her comments tend to be brief, and often scurrilous, referring to her as 'like a mummified cat' (*Letters*, 24 January 1934) and 'Old stringy' (*Diaries*, Friday 1 November 1935, The Hogarth Press).

She was created a DBE in 1958.

Cambridge University

Cambridge gradually became a leading university town in Europe. At first most students lived in hostels, and then in the later thirteenth century the first colleges were built, Peterhouse (1284) being the oldest and the smallest. During the Reformation period, Cambridge produced many charismatic leaders, including Thomas Cranmer, and Matthew Parker, initiating national religious and social reform.

Further reforms in the 1850s transformed Cambridge from a small medieval university into the modern centre of learning for which it is distinguished worldwide today. Colleges for women were founded from 1869, but they were not permitted to gain university degrees until 1948.

Samuel Pepys, who has been mentioned in connection with his uncle's property in Cambridgeshire, following his schooling at St Paul's School, London, went on to become a student at Magdalene College, Cambridge, in 1651. Not much is known about his scholarly activities there. He graduated in 1653, and took up employment with the Admiralty in London, but visited his college from time to time. He mentions having a beery session at the Three Tuns in the town, and in 1667 decided to explore the college Butteries, where food and alcohol was stored, 'and there drank my bellyful of their beer, which pleased me as the best I ever drank'.

Following his death, he bequeathed his famous Diary and other manuscripts, books and prints to his former college, along with the bookcases they were housed in. The university created the Pepy's Library in the Second Court of Magdalene so the total bequests could be kept together and enjoyed for the benefit of students, visitors, and research historians.

Abraham Cowley (1618– 67) was born in London, and while still young was inspired by reading Edmund Spenser's *Faerie Queen* (1590) to become a poet himself, writing verses from the age of ten.

In 1637 he commenced study at Trinity College, Cambridge, and was later elected a Fellow. However, he was ejected from the role by the Parliamentarians in 1644 during the Civil Wars and moved to St John's College, Oxford.

He became quite a prolific poet and gained celebrity as the greatest of his period. *The Mistress*, love verses written in a variety of irregular metres, was published in 1647 and republished with *Miscellanies*, *Odes* and the *Davideis* in 1656.

Following his death his reputation rapidly declined as his poems became considered lacking in character and generally rather dull. However, he is accorded a place here because of the beautiful lines he wrote recollecting the death of his friend William Harvey and the blissful time they spent together in Cambridge:

Ye fields of Cambridge, our dear Cambridge, say
Have ye not seen us walking every day ?
Was there a tree about, which did not know
The love betwixt us two ?
Henceforth, ye gentle trees, for ever fade,
Or your sad branches thicker join

And in some darksome shades combine
Dark as the grave wherein my friend is laid.

<div align="right">From 'On the Death of Mr. William Harvey'</div>

Celia Fiennes (1662–1741), diarist, was born in Newton Toney near Salisbury. When she was in her thirties, she travelled extensively throughout England and Scotland, riding side saddle, or by coach, and staying mainly with relatives or in local inns. Her ostensible purpose was to improve her health and also, she said, out of curiosity to explore new and varying regions.

Her journeys were made chiefly between 1685 and 1703, and her longest period of travel was in 1698, covering over a thousand miles. She visited Bury St Edmunds in *c.* 1700, but before that, Cambridge in 1697. She toured Trinity College, and in the Library, designed by Sir Christopher Wren, she greatly admired the craftsmanship of Grinling Gibbons, commenting, 'the finest carving in wood in flowers, birds, leaves, figures of all sorts, as ever I saw'. She also noted that the Fellows and Gentlemen Commoners in the various colleges, could have 'a large dining-room, a good Chamber, and good Studdy, for £8 a year'.

Her Diaries were not published until 1888, under the title *Through England on a Side Saddle in the Time of William and Mary.*

William Wordsworth (1770–1850) is acclaimed as one of England's greatest poets and was appointed Poet Laureate in 1843. His particular originality is his unique expression of what nature meant to him: 'No one has ever surpassed him in the power of giving utterance to … some of the most elementary sensations of man confronted by the eternal spectacle of nature' (Sampson, George, *The Concise Cambridge History of English Literature,* Cambridge University Press, 1961).

Born in Cockermouth, Cumberland, he became a student at St John's College, Cambridge, in 1787–91. While there he made a point of visiting the poet John Milton's rooms in Christ's College, and drinking a toast to his renowned memory, as he recorded later in his long autobiographical poem *The Prelude.* In *The Prelude,* he also records his impressions of first arriving at Cambridge:

Delighted through the motley spectacle;
Gowns grave, or gaudy, doctors, students, streets,
Courts, cloisters, flocks of churches, gateways, towers:
Migration strange for a stripling of the hills,
A northern villager.

He also wrote some other poems and sonnets recalling his time there, including *Inside of King's College Chapel* (1820), with a fine description of the interior elaborately vaulted ceilings:

the branching roof
Self-poised, and scooped into ten thousand cells
Where light and shade repose, where music dwells,
Lingering – and wandering on as loth to die.

William Wordsworth – wood engraving by Diana Bloomfield, 1974. (© Oxford University Press)

Most of us know this famous ceiling best, admiring it every Christmas when the BBC TV *Carols at Kings* is screened and the cameramen lovingly play their focus over all its exquisite carved detail, illuminated by both winter afternoon light and then increasingly the warm colours of candlelight.

Following graduation and establishing himself as a distinguished poet, he revisited Cambridge with his sister Dorothy in 1820, to visit their brother Christopher who had enjoyed a prestigious career at Trinity College, elected as Master and also Vice Chancellor. They were accommodated in the Master's Lodge, and Dorothy recorded in her diaries, 'All is so quiet and stately, both within and without doors.'

A 'small but zealous band' of undergraduates was invited to meet the celebrated poet, and one of them, John Moultrie, wrote verses recording his impressions, which are quoted in Mary Moorman's biography of Wordsworth.

George Gordon, Lord Byron (1788–1824) studied at Trinity College (1805–08) and had rooms in Nevile's Court. In his Letters of the period, he writes,

I like a College Life extremely ... I am now most pleasantly situated in Superexcellent Rooms, flanked on one side by my Tutor, on the other by an Old Fellow, both of whom are rather checks to my vivacity.

He soon discovered that the prevailing mood of Trinity College was laziness and levity:

Study is the last pursuit of the Society; the Master eats, drinks and Sleeps, the Fellows drink, dispute and pun, the employments of the Undergraduates you will probably conjecture without my description.

In his case there was a romantic love affair with a fifteen-year-old choir-boy, to whom he presented a beautiful heart-shaped pink cornelian in a gold ring, and drooled, 'I certainly love him more than any human being.' His other great affection was for his bear, Bruin, whom he described as 'the finest friend in the world'. Dogs as pets were forbidden at Cambridge, but nobody dreamed that a bear would become an inmate, lodging in stables near Trinity College.

Byron wasn't simply showing off in his customary flamboyant manner, but making the joke that Bruin would be sitting for a Fellowship, as a serious criticism of the low academic standards prevailing.

Byron went on to become a major poet, with works such as 'Childe Harold's Pilgrimage', commenting on its publication in 1812, 'I awoke and found myself famous', and becoming a formative figure in European Romanticism.

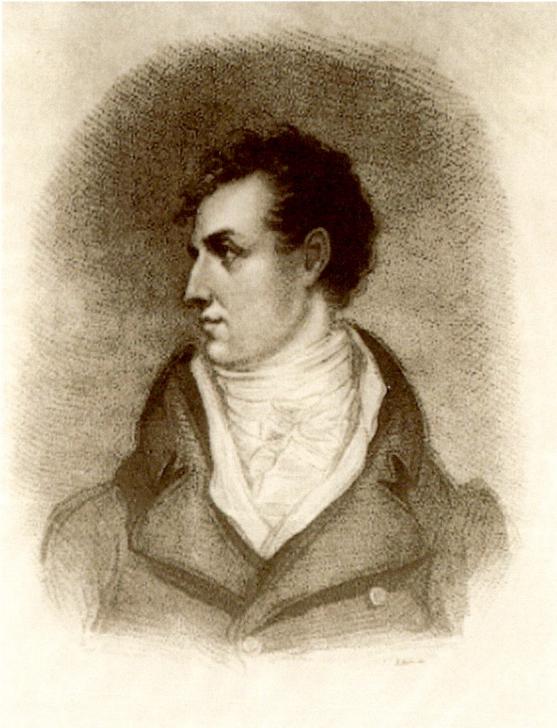

George Gordon, Lord Byron – sepia print. (© Yale University Press)

Charles Kingsley, historian and novelist, was a student at Magdalene College from 1838 to 1842, and was subsequently appointed Professor of Modern History in 1860. His novel *Alton Locke*, published in 1850, has various scenes set in Cambridge.

Sir Leslie Stephen (1832–1904) studied at Trinity Hall from 1850 to 54, and became a Fellow of Trinity Hall after graduating in 1854–67. In his biography of his friend and colleague Henry Fawcett, he provides a description of the Fellows' Garden, 'which Mr. Henry James – a most capable judge – pronounces to be unsurpassed in Europe'.

He was a prolific writer, philosopher, biographer and essayist and is best known for writing and editing *The Dictionary of National Biography* (1882–91), which continues to be revised and updated today, and includes the celebrated writers of Norfolk, Suffolk and Cambridge. His daughter, Virginia Woolf, delivered a lecture, in 1928 at Newnham College, established for female students in 1875, on the importance of higher education and independence for women.

The students tended to find her manner formidable and not altogether sympathetic. One of them at least remembered the effect the lecture had on her with remorse. Woolf's 'mellifluous, cultivated voice, reading from her manuscript,' combined with the darkness of the lecture hall, created a 'lullaby effect, and I am deeply ashamed to confess that I slept right through it. If only I had known it was going to become A Room of One's Own!' This was the long essay, now regarded as a great feminist classic, arguing that a woman needed 'money and a room of her own if she is to write fiction'.

Virginia herself later wrote in her Diary that the girls were 'Intelligent, eager, poor; & destined to become schoolmistresses in shoals ... I felt elderly & mature. And nobody respected me...'

Edward Morgan (E. M.) Forster (1879–1970) was educated at King's College and later elected Fellow, and lived in King's College from 1946 to 70.

A member of the Bloomsbury circle and a friend of Rupert Brooke, Forster became regarded during his lifetime as one of the greatest English novelists, with works including *Howard's End* (1910) and *A Passage to India* (1924). He delivered the Cambridge Clark lectures *Aspects of the Novel* in 1927. In *The Longest Journey* (1907) Forster describes the main character as being educated at Cambridge, a pleasant experience after the rigours of a public school, an institution which Forster thought responsible for 'the undeveloped heart', a constant theme in his novels. The university 'had taken and soothed him, and warmed him, and had laughed at him a little, saying that he must not be so tragic yet awhile'.

He was elected to the elite society of the 'Apostles', which included art historian Roger Fry, Desmond MacCarthy, Leonard Woolf, Lytton Strachey, the economist John Maynard Keynes, and Forster's close friend Goldsworthy Lowes Dickinson, whose *Life* he wrote in 1934, describing the happiness both men had found in the studious academic environment:

> As Cambridge filled up with friends it acquired a magic quality ... people and books reinforced one another, and intelligence joined hands with affection, speculation became passion, and discussion was made profound by love.

Well, we now end our literary travels throughout East Anglia, and I hope you will enjoy making friends with many engaging personalities, and be inspired by various poetic geniuses, as I have.

This book should also encourage you to travel around our regions and visit the places associated with our various authors – humble cottages and stately homes, ancient churches and abbeys, castles, remote farmhouses, seaside resorts, river pastures – enjoying the ever-changing wide-skied shimmering landscapes for which East Anglia is renowned, and which have inspired so many local artists as well as writers.

Acknowledgements and Bibliography

My chief debts of gratitude are to Martin Evans, who once again has been of valuable assistance in dealing with assembling the photo illustrations (he is not involved with any copyright issues) and Karen Leah, who has created the three county maps at the beginning of the text.

Publication acknowledgements are as follows:

Betjeman, John, *Collected Poems* (Methuen publications, 1980)
Woolf, Virginia, *A Passionate Apprentice – The Early Journals* (Hogarth Press, 1992)

The copyright permission for: Baldry, George, *The Rabbit Skin Cap,* Collins Press 1939) – Cheyne family, Ditchingham. And Rider Haggard, Lilias, *A Norfolk Notebook* (Faber & Faber, 1946)

Barker, George – poem 'At Thurgarton Church', copyright Thigrame press and Christopher Barker
Blythe, Ronald, *Akenfeld* (Allen Lane the Penguin Press, 1969)
Byron, Lord George Gordon, – quotations from his letters in Coote, Stephen, *Byron*
Cobbett, William, *Rural Rides,* two vols. (Everyman's Library, J. M. Dent & Sons, 1957)
Ishiguro, Kazio, *The Buried Giant* (Faber & Faber, 2015)
Mann, Mary, *Tales of Victorian Norfolk* (Bungay: Morrow & Co., 1991)
McEwan, Ian, *The Child in Time* (Vintage Books, Penguin, Random House, 2023)
Rupert Brooke letter, quoted in Hastings, Michael, *The Handsomest Young Man in England* (Michael Joseph Ltd, 1967)
Cornford, Frances, ibid. – verses –page 18.
Sebald, W. G., *The Rings of Saturn* (The Harvill Press, London, 1998)
Sir John Suckling – Aubrey, John, *Brief Lives* (The Boydell Press, 1982)
Spender, Stephen, *W. H. Auden – A Tribute* (Weidenfeld & Nicholson, 1974)
Tennyson, Julian, *The Suffolk Scene* (Blackie & Son, 1939)
Tremain, Rose, *Restoration* (Vintage Books, Penguin Random House, 1989)
Williamson, Henry, *Tarka and the Last Romantic* (Anne Williamson, Sutton Publishing, 1995)

Virginia Woolf lecture, quoted in Lee, Hermione, *Virginia Woolf* (Chatto & Windus, 1996)

Woodforde, James, quotations –*The Diary of a Country Parson, 1758–1802* (Oxford University Press paperback edition, 1986)

Peter Tolhurst's *East Anglia, A Literary Pilgrimage* (Black Dog Books, 1996) is an excellent source of information for local authors, and the following black and white photos are credited to him: pages 11, 40, 51 and 69. The author and publisher would like to thank the organisations listed above for use of copyright material in this book where required. Every attempt has been made to seek permissions for restricted copyright material; however, if we have inadvertently used material without permission we apologise and will make the necessary correction at the earliest opportunity.